Training Days

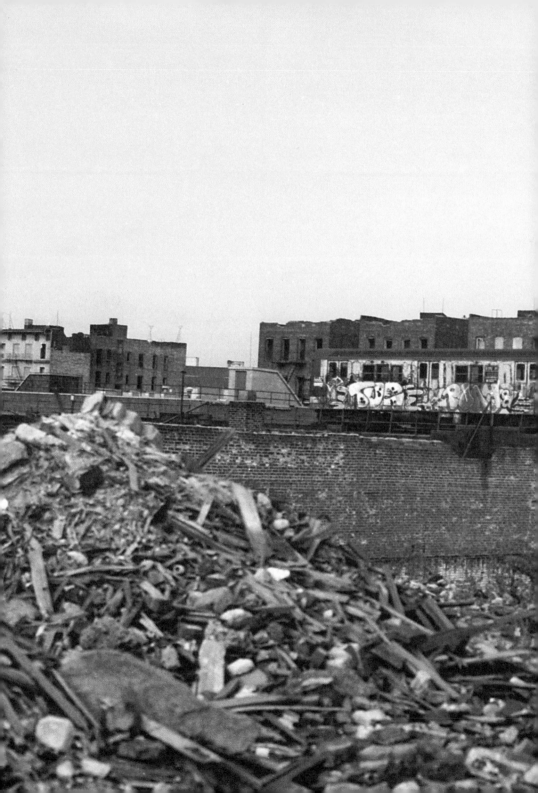

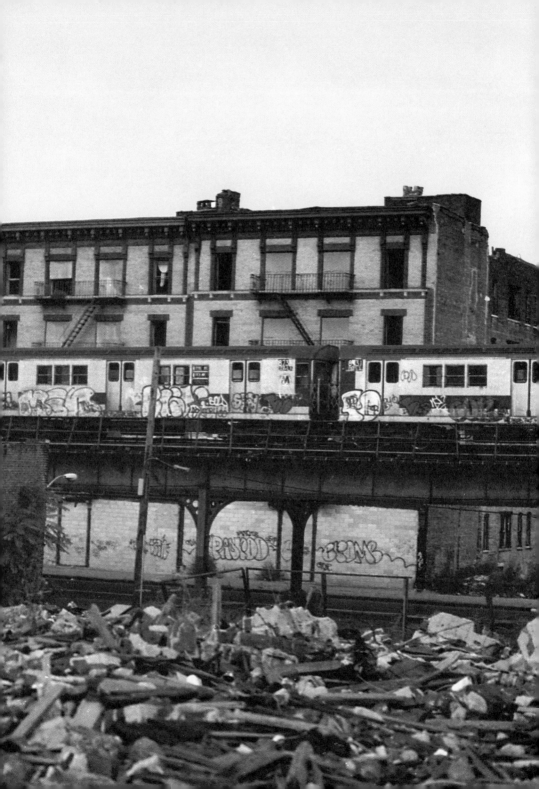

Training
Days

The Subway Artists
Then and Now

138 illustrations, 133 in color

Thames & Hudson

Acknowledgments

HENRY

I'm forever grateful to all the writers who taught me everything I know about the art; and to Thames & Hudson who saw in my photos (and Marty's) the material for *Subway Art*, published exactly thirty years ago. Thanks to Thomas and Connie Neurath and Ronnie Davidson-Houston for shepherding the project then and to Steve Russell and the current Thames & Hudson crew for carrying it on into the present. Thanks to my collaborators in all my projects that grew out of this movement—Martha Cooper, Jim Prigoff, Tony Silver, Rita Fecher, Steve Zeitlin, Sacha Jenkins, and Carl Weston. Working with you has been and continues to be inspiring and essential. I couldn't have done this book without the tireless work, over more than a decade, of Nathan Fox and Max Hergenrother, who digitized and stitched 824 trains. Thanks to the Scrap Yard in Soho, for keeping my work available to the grass roots. I'm most grateful to my wife, Kathleen, for her constant support and putting up with the "less traveled" path I took, and to my kids, David and Andromache, who have shared their dad with so many "siblings."

SACHA

Thanks to Henry Chalfant for being a mentor, friend and father figure in a world where fathers aren't promised. To Daze, Skeme, Bil Rock, Kel 1st, Spin, Lady Pink, Team, Breezer, Sharp, Jon One 156, Sak MBT, and Kr. One: THANK YOU for being crazy kids who weren't afraid to perform wild gymnastics on the third rail. To our friends at Thames & Hudson: thank you for publishing *Subway Art*—a book that changed the lives of many young people around the world and helped to further this beloved culture of "writing" long before the internet; thanks to Steve and the team at Thames & Hudson for helping to make this very book something else. Shout out to my wife Raquel, seeds Djali and Marceau 1, my parents, family, extended family, and ancestors. Thanks to the homies Chino BYI, Haze, Kaves, Reas AOK, SP. One, San 2, Grabr, Mass Appeal, Decon, White Mandingos, Super Black, and all the rest.

Training Days: The Subway Artists Then and Now © 2014 Henry Chalfant and Sacha Jenkins

Designed by Steve Russell

First published in 2014 in hardcover in the United States of America by Thames & Hudson Inc., 500 Fifth Avenue, New York, New York 10110

thamesandhudsonusa.com

Library of Congress Catalog Card Number 2014932771

ISBN 978-0-500-23921-6

Manufactured in China by Imago

Contents

Preface by Henry Chalfant 10

Of Kings and Blue-Collar Writers by Sacha Jenkins 16

Interviews

Bil Rock 22

Breezer 34

Daze 44

Jon One 58

Kel 70

KR 84

Lady Pink 92

Sak 104

Sharp 114

Skeme 128

Spin 142

Team 160

Glossary 170

Index 173

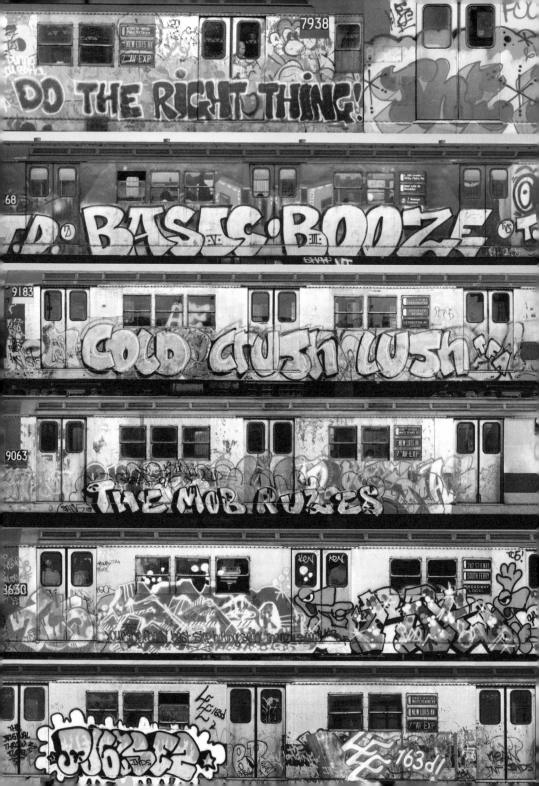

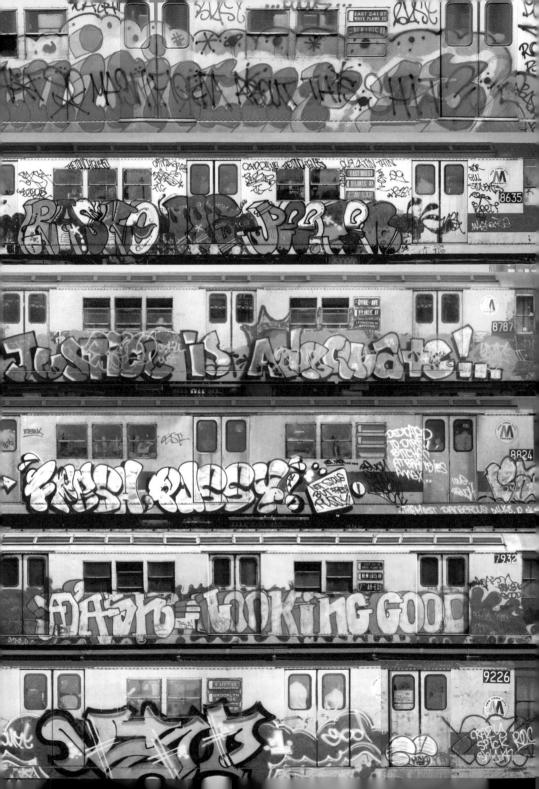

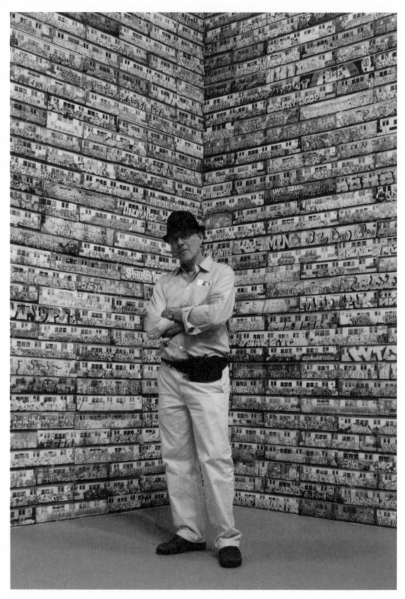

Henry Chalfant in front of his installation at MOCA, Los Angeles, in 2011, which featured more than 800 painted subway cars.

Preface

Henry Chalfant

My first serious photo expedition to the Bronx to hunt for trains on the elevated took place in the summer of 1977. One weekend, I took the uptown 2 train from the 96th Street and Broadway station near my home. As the train climbed out of the tunnel at 3rd Avenue and 149th Street, I saw a string of trains parked on the track. The sides were covered with throw-ups and burners. As we approached Intervale Avenue, the Fabulous 5's *Merry Christmas* married couple (p. 13) came into view. I wanted that picture so badly! I decided to get off at the next stop and see what I could do. As the two cars were parked in between stations, I only had one option: to make my way along the catwalk that workers used for track work. Intervale Avenue takes its name from the valley in which the neighborhood was built, and the elevated track lies on a trestle high above the street. I knew that the trains ran about every ten minutes on weekends, but there were two lines—the 2s and 5s—using the same track, and there was no way to tell how soon the next train might come. So, knees shaking, I walked out to where the *Merry Christmas* train was parked. Using a technique to create a panoramic image that I had learned as a sculptor, I took about a dozen overlapping shots of those two cars, before running back to the station and climbing onto the platform, provoking curious and somewhat disdainful looks from the waiting passengers. As I hung about at Intervale station that day, I was able to apply the same shooting technique to some additional pieces on the trains stopping on the track opposite, on the downtown side of the platform. This was the launch of my subway art collection. Over a seven-year period, I accumulated more than 800 images of subway art.

That was a landmark year for New York City. It was the year that Son of Sam, the serial killer who stalked the city for months targeting young

couples, was caught. And it was the year of the blackout that triggered widespread looting and fires. According to old-school graffiti writer James Top, the blackout was the event that gave birth to hip hop. The spoils of the looting included huge quantities of spray paint and electronic equipment such as speakers, amplifiers, and turntables—enough material to expand the power and reach of the art and music that the young kids were creating. I once watched James Top in an interview with a reporter from the *New York Times*, in which he said of the blackout: "That was the moment when we understood that we had real power."

After my first foray into the Bronx, I began to go every weekend to one of the elevated stations on the 2 and 5 lines. Sometimes I switched lines at the Grand Concourse and took the uptown 4 train, which also ran outside on an elevated line past Yankee Stadium. Another favorite spot was 125th Street and Broadway in Manhattan, where the 1 train briefly emerges into daylight before plunging back into the tunnel on its journey to 242nd Street. By 1978, the New York City Transit Authority had expanded its "buffing" facilities and was running all the trains through large, environmentally damaging chemical car washes. As a result, there were very few pieces running that year. However, from the elevated stations I could see the many graffiti pieces on the streets and handball courts of the Bronx. I decided to add those to my growing collection and began to wander the streets of the neighborhood with my camera. I was able to witness first-hand the devastation that was taking place there, the abandonment and fires that were ripping through the borough, creating the now famous wasteland.

One Saturday, I happened upon a curious scene in a park near East Tremont Avenue, where kids had gathered and were setting up gigantic speakers, amps, and turntables. I approached but quickly realized that I had come to the attention of a menacing Latino gang wearing colors. I don't remember the name of the gang, but they were all dressed in green. I overheard one of them say to another, "Te sacó una foto." "Uh oh," I thought. The guy came up to me and literally lifted me up by the lapels,

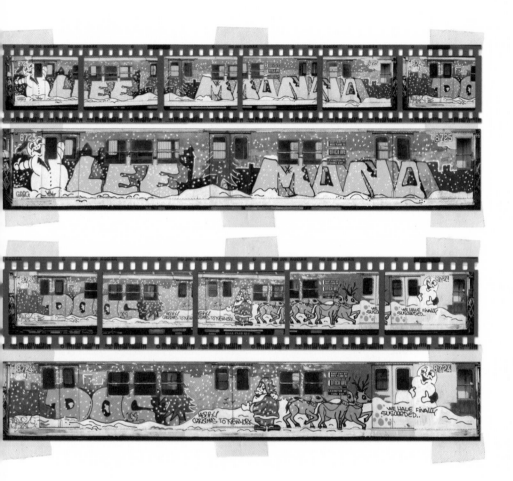

The Fabulous 5's *Merry Christmas* married couple, painted by Lee, Mono, and Doc, 1977.
These images show Henry Chalfant's technique for documenting the trains, shooting
a series of photos of each car from close-up and splicing the resulting
prints in the studio.

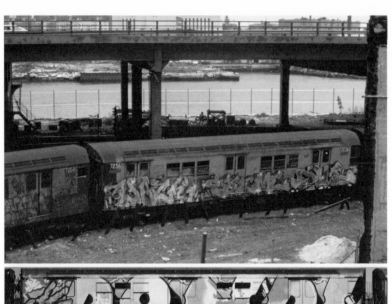

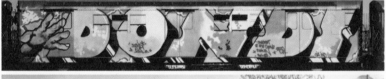

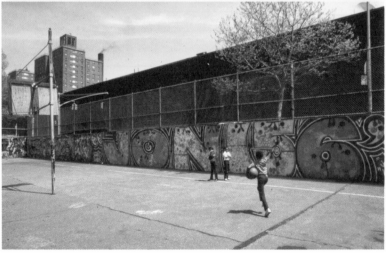

like a cartoon character. "You took my picture," he said. "No, no, this is what I'm doing," I replied, showing him some pictures of graffiti I had in my pocket. He shuffled through them with interest, as his companions gathered around, and then said, "Okay, I'll let you go, but if I see my picture in the paper, you're dead!" Needless to say, I made a quick exit, but it is one of my lasting regrets that I didn't stay long enough to see—and photograph—what I now realize was a hip-hop park jam.

In April 1980, there was a transit strike. Graffiti writers seized the opportunity to paint undisturbed, day and night, for almost two weeks. Dondi painted his famous *Children of the Grave, Part II* during the strike, making the most of being able to create his masterpiece at leisure. Other writers also took advantage of the moment and created many masterpieces and burners, making 1980 a very good year. This was one of the few times in history that writers were able to work as if they were in a studio, with plenty of time to paint carefully and make corrections. Conditions were not usually so favorable, with the dirt, darkness, and cramped space, as well as the many dangers from police raids, worker assaults, beat-downs, and paint thefts from rival crews, turning the whole process into something more akin to performance art in a war zone. These special circumstances have spawned a rich trove of stories, many of which have remained untold until now.

Over the years, in a natural desire to portray the movement in the best light, those who documented the scene—myself included—chose to exhibit the freshest, most thoroughly finished trains. We told the stories of kings and masters, those artists who had the greatest impact, and we selected their best work. This has given the world a distorted picture of graffiti. It's time to paint a more complete picture, and we've only scratched the surface. There's a story to go with every painting.

ABOVE Daze, Skeme, Due (Dez), 3 yard, Harlem, 1982. **CENTER** Dondi's *Children of the Grave, Part II*, painted during the transit strike of 1980. **BELOW** Jon 156 (Jon One), Graffiti Hall of Fame, East 106th Street and Park Avenue, Harlem, 1984.

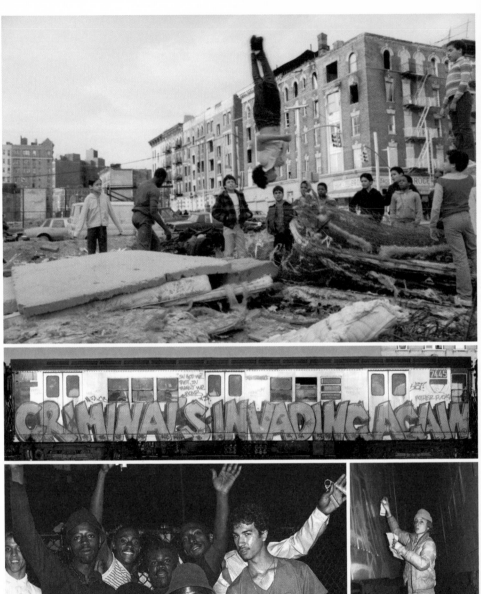
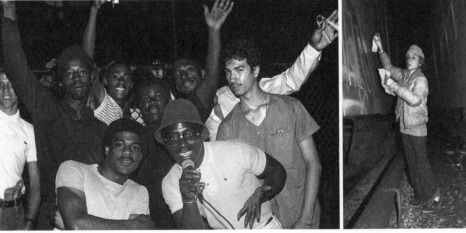

Of Kings and Blue-Collar Writers

Sacha Jenkins

Every writer has a story to tell. It's not just about the king who dominated your local line. There are four-star generals and privates alike who have views to offer up regarding the subway writing movement. This book aims to draw a nice crispy outline and fill it in with tales that illuminate what it felt like to call yourself a writer before crack cocaine grabbed hold of so many young people in New York City.

Back when New York didn't have much, the kids had to figure out what to do with themselves. This was before video games, before that black hole we call the World Wide Web emerged. The kids who ran through the cool fire hydrant blasts that sprayed temporary relief in the tar-boiling summers were adventurers, explorers, archeologists, Picassos, and, to a certain extent—ahem, cough cough—vandals. What do bored big-city kids do when they're looking for swashbuckling adventures inside a concrete jungle? They write their names inside subway trains and, eventually, on the exteriors of said trains.

In the late 1960s, New York City had to tighten her belt. By the early 1970s, that same belt started to lose catch. The things that everyday people take for granted—garbage pickup, public education, and the efficiency of a transit system—would soon take a fall when the belt totally came undone. New York City was on the verge of bankruptcy. The kids in New York City, however, have always been scientists (in addition to being explorers and archeologists): scientists because, in the face of adversity, they created

ABOVE Kids demonstrate their acrobatic skills amidst the devastation on Hoe Avenue, Bronx, 1985. **CENTER** *Criminals Invading Again*, painted by members of the CIA crew, 1981. **BELOW LEFT** A park jam in East Harlem, 1983. **BELOW RIGHT** Min paints in the New Lots Avenue train yard, Brooklyn, 1981.

cultures that would change the way people around the world communicate (which means that they could be considered linguists, too).

Take the music education programs out of an ailing school system and the kids in New York will laugh at you and tell you to "Throw your hands in the air, and wave 'em like you just don't care." The turntable—initially employed as a tool at humble outdoor block parties—would be transformed into an instrument, with cutting and scratching being the South Bronx's answer to a Jimi Hendrix guitar solo. Throw in boastful poetry and toasting and a series of elaborate and physically demanding dances (uprocking, B-boying, breakdancing), and what you have is a snapshot of a movement called hip hop.

When hip hop was synthesized in the press way back in 1980, the rap music/breakdancing/graffiti trinity made perfect sense because, in spirit, all three come from the same place: the wild, raw energy of New York City street life. Rap music, even today, is often about puffing up your chest and flaunting your superior posture like a peacock hovering atop the Empire State Building. Some people say that writing or "graffiti" has nothing to do with hip hop or rap culture because it pre-dates the recorded music. Blade remembers listening to news on the Vietnam War on his nifty transistor radio while painting a train in '73, when Kool DJ Red Alert wasn't even on the radio. The Sugar Hill Gang were probably eating lots of candy back in '73, for that matter.

Certainly writers or "graffiti writers" were exhibiting the flavor, the attitude, the desire to be the best—the competitive nature that exists in rap music today—way before Run DMC stomped on stage in Adidas Superstars. That arrow, that #1 with the curly flourish that makes the digit look like a capital "L" in script, that smooth halo that lives above a signature and protects it, that drippy star that resides to the left and right of

ABOVE G-Man and his crew set up for a park jam in the Patterson Playground, Bronx, 1983.
BELOW B-boy on the Coney Island boardwalk, Brooklyn, 1985.

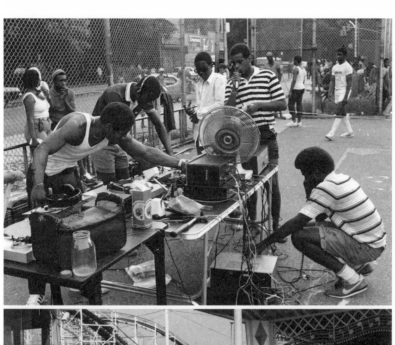

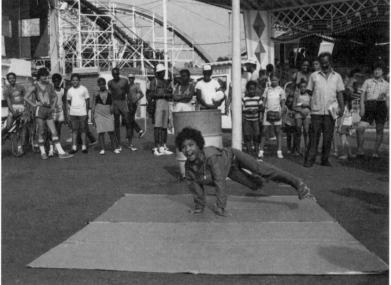

a signature: these are accoutrements that scream, "I am here. You can't ignore me. I am different. I stand out. I am the best. Recognize me. Battle me and you will be defeated. Test me at your own risk."

Before there were rappers earning fans at local jams and eventually jams in space, the writers were the ghetto celebs you wanted to meet. Their monikers, in certain instances, were just as familiar as the Colgate and Afro Sheen advertisements often seen hugging the side of a crosstown bus. The writers were platinum artists, with fame and groupies and crazy stories attached to their legend. Their "brands" would become household names, while the expression itself would evolve, growing from stylized signatures to full-blown Technicolor dreamscapes.

Writers from the bygone eras are an endangered species because New York City will never be the same. Everywhere you look, you find a camera winking at you. And while there are still out-of-town graffiti conquistadors willing to risk it all to paint the subways there, the penalties that await you, should you get caught, are stiffer than a dead pharaoh in a blinged-out pyramid. The traditions of the writers' movement have been stifled by an aggressive Vandal Squad that goes after the big fish in the big pond; no human wants to get the ceviche treatment, especially not for "bombing" a train. In the old days, you would learn the art of getting over from a mentor who knew the ropes: he showed you how to get in the train yard, where and how to steal spray paint, how to convert your mother's deodorant and the eraser from your math class into a juicy magical marker. Today, there's a kid from the Midwest on the Net who will show you how to make that marker, if you're interested.

The photographs in this book are taken from Henry Chalfant's extensive collection of subway graffiti. His images were first seen in *Subway Art* (1984), and it was those images that, in many cases around the world, helped to birth a nation of writers. *Subway Art* showed us beautiful masterpieces. This book, on the other hand, looks to the voices of these characters to fill in crucial blanks that even arresting photography can't fully do justice to. The voices you'll hear in these pages belong to ghosts

from the old New York who continue to push the envelope as artists and as individuals in a brand new millennium. They're still adventurers, explorers, archeologists, Picassos, linguists, ex-vandals. They hail from diverse backgrounds, different socio and economic strata, a plethora of crews. But after you've read their graffiti narratives, you'll walk away with a vivid picture of what the writing community was like when the Transit Authority looked to Nazi Germany for fight-back strategies: razor-festooned, circular barbed wire and German shepherds, for example, would surround and patrol the no. 7 yard.

Here's to the writers who rolled to the yard with raw steaks, knowing, deep down, that every creature has its price. And to Chalfant and Cooper, for opening our eyes.

BIL ROCK

Hailing from Manhattan's Upper West Side, Bil Rock was a writer's writer. He bombed, he socialized, he organized. The crew he ignited—Rolling Thunder Writers—is one of the most respected collectives ever to pick up a Uni-Wide marker and was prolific in all modes of aerosol expression. From tags to throw-ups to full-on masterpieces, Bil Rock's legacy lives on, not only through his own subterranean victories, but also through the outreach provided by the spray-paint-donning ninjas he raised and inspired.

My first interactions with graffiti must have been when I was in fifth grade, which would have been 1972. You can think what you like about the Upper West Side, but it's nothing like it was when I was a kid. Back then, it was very different: there was a gang on every corner and a lot of graffiti. I remember being pretty young and being well aware of guys like Cat 87 and Taki 183 bombing walls. The neighborhood was *killed*. It really wasn't until the following year—so '73, or maybe '74, when I ended up going to IS 44—that my relationship with graffiti became more direct. IS 44 happened to be the local junior high school for all the graffiti writers who lived on the Upper West Side. Haze went there.

I would say '74 was when I started. That's when I met the Edmonds brothers, Mark and Michael—Ali and Little Ali—which was a life-changing experience. I also got to know Malta and Steve 61, who turned me onto writing. They were like my big brothers. I wanted to be like those dudes! Writing was embedded in my neighborhood's culture. Haze lived on 86th Street, Revolt was from 81st, and I was right around the corner on 82nd. The culture was centered around the Bandshell in Central Park and, to a lesser degree, the YMCA. Ali's family was big in the rent strike movement at the time, which was huge on the Upper West Side. Everything was very counterculture, very left. I was 12 years old when I joined the Soul Artists, and I wrote Sage.

It was awesome. I was schooled in places like Noga, and I knew everyone. Then, at some point, I got sent away to reform school and that was the start of a whole new chapter: the creation of RTW. Some of the first RTW dudes were from that reform school. I was very young, 13 or so. I had been arrested several times for theft, and breaking and entering. I used to break into construction sites and steal all the power tools and stuff like that. It was just a neighborhood thing: we all did it.

My parents were crazy pissed off, but they were cool. They were beatniks. My dad was a jazz musician, and my mother was a painter. I drove them mad. We lived on the first floor and, at the peak of my graffiti activity, people from every borough would come and knock on the window.

My mother was going to Columbia's graduate school and ended up writing a paper on graffiti. She interviewed a whole bunch of us. I actually have that paper—an early, unpublished study—buried in a box somewhere. Being an artist, my mother thought graffiti was cool. She could see the bigger picture—beyond "vandalism" or tags, or whatever. My dad was like, "*Whatever.*" But he'd get off the train and say, "I saw Sage all over the train."

Dudes like Min would drive them crazy, though. If you were a member of RTW, you were inevitably abused by Min at some point. He was really arrogant and got away with a lot of things because of his size, but he was also very smart. He'd get a lot of us to fight his battles, and half our beefs were of his making. He was in my neighborhood and also ended up going to the same reform school soon after I had arrived there. I was there for a year and ten months, but they'd let me go home one weekend a month, as long as I stuck to my program.

When I got out of reform school, it was 1976—the year RTW was born. It seemed like the Soul Artists and other clubs were dead, and I was tired of hitting up all these dead clubs. Ali had gotten burned in the 1 tunnel—literally—so he quit writing. Malta was done by '75, '76. The only guys still writing were Crunch, Haze, Zephyr, Revolt, and me. That was it at the time. We needed to start something new.

One day we were hanging out, tripping on acid. At the time, my sister had a Native American boyfriend, and they both worked for AIM, the American Indian Movement. She had given me this book about a Native American healer dude, a shaman kinda guy, named Rolling Thunder, which I had with me. As we were all tripping out, our boy Joe pulled out an album, Mickey Hart's *Rolling Thunder*. I looked at that LP and I looked at the book and I was like, "Man, this is it! Let's make it the Rolling Thunder Writers." Our first shit was throw-ups on the walls of Brooklyn College.

FROM TOP TO BOTTOM Sage (Bil Rock), IRT Broadway Local (1 line), 1979; Crunch, ES III (SE 3); Bil (Bil Rock), Revolt, 1980; Zeph (Zephyr), 1980.

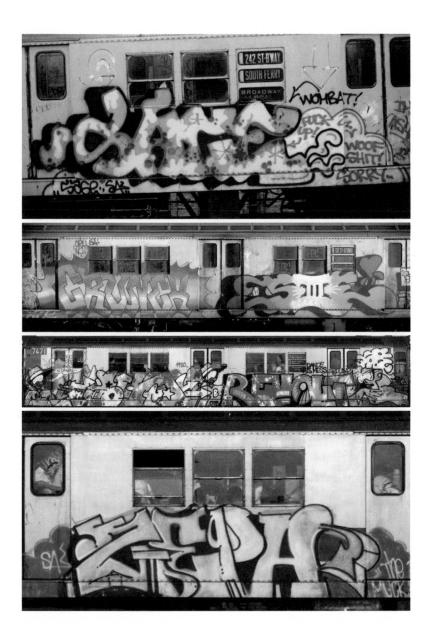

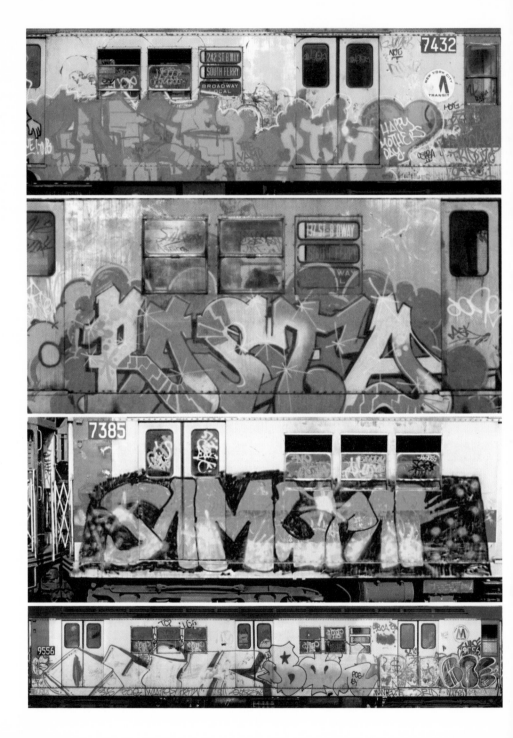

Bob Marley would play at the college, and Hot Tuna too. I was hanging out tough on Glenwood Road back then. That was when the neighborhood was still largely Italian and Jewish, rather than West Indian, as it is today.

In the winter of '77, we started hitting the 1 tunnel and the 1 elevated lay-ups. By "we," I mean Revolt, Zephyr, Min, Rasta, and me—the five main fingers of RTW—and Samurai and Strike. Quik didn't join us till late '79. Then Iz came along, and Sach. We were crazy kids and nothing like your traditional writer or whatever you imagine a graffiti writer to be, white or non-white. We were nothing like the white MG boys, you know? And we were nothing like TNT, who were all black and didn't get us. We just didn't fit in. We were sliced right down the middle. Probably half my crew was mixed race or something anyways. That was the neighborhood we came from. It was so mixed on the Upper West Side. It was very hippie—not sandals and Grateful Dead, but more like sneak cokeheads and Sly & the Family Stone. We were like hippies but street smart.

Most of the time, I had great fun and didn't have any problems, but right off the bat I had trouble with two clubs. It was more territorial than anything. One of them was TNT. They just couldn't understand these freaks invading the tunnel. They'd never seen anything like it. We were aware that when we walked into a tunnel, there had better be a few of us or we might run into difficulty. I also had problems with dudes like Jayson and the Mob, even though we had a connection to them through Zephyr, who had been a member of the Mob from the beginning, around '76.

I remember originally we even had beef with Dondi. I think I had backgrounded one of his pieces in the 1 tunnel. It was probably one of those nights when all the bulbs were broken and I couldn't see that well. I had no reason to go over him. Anyways, I admired his stuff. One day, I'm in the tunnel with a bunch of dudes, maybe fifteen of us. Next thing

FROM TOP TO BOTTOM NE (Min), 1 line, 1982; Broadway Rasta, 1982; Samurai, 1980; Quik, Bil (Bil Rock), 1982.

you know, twenty guys come pouring in from the other side. Turns out it was Dondi, Kase 2, Kel, Crash, and Shy. Me and Dondi just talked straight up. I told him I hadn't intended to do that to him and that it was a mistake. He was totally cool and, from that day on, RTW and CIA were like brother clubs. They still are, for the most part. It was heavy at the time, though: it looked like it might turn into a fight, but intelligence prevailed on both sides. We all ended up being close through the early 1980s, then hitting galleries and all that stuff.

The downtown/uptown connection is important because that ties us in with not only the Go Club, but also dudes like Jean-Michel Basquiat and Al Diaz—the whole downtown scene. We were definitely Upper West Side, but we dated a lot of the girls in the Village. I went out with a girl who had dated Me 62 from the Go Club. I don't know why, but we'd cross each other out all the time. It was like a war. We never ran into each other, but there was this weird connection between us and I was very wary of those dudes. They were just very different from us, and there was a little bit of a racist vibe at one point, basically because of a guy named Piggy. Team is cool, though, and a sharp cookie. He was the prez and the brains, but Piggy was the muscle and the craziness. They terrorized the Village. Dudes like Pade, who was from the Village, used to get their skateboards yelped.

One time, I wound up in some fight. I was fighting like five dudes at this party on the Upper West Side. I got knocked down into a basement where some dudes were playing pool. When I got up, Me 62 and all these Go Club dudes were around me, and they were like, "Yo, Rock, we got your back, man." The next thing you know, they had slashed the dudes I was fighting. From then on, we were friends.

It started getting crazy, though. By '77, '78, people were shooting at each other and, you know, there were beefs that would get outta hand. By

ABOVE Sach and Quik at Rockaway Boulevard, Queens, during the *Style Wars* shoot, 1982.
BELOW Bil Rock, Min, and Kel in the City Hall lay-up at night, 1983.

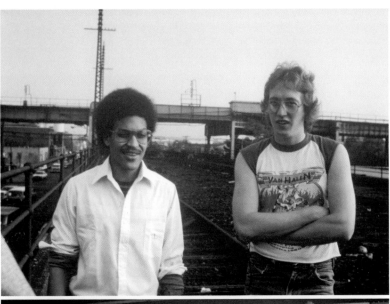

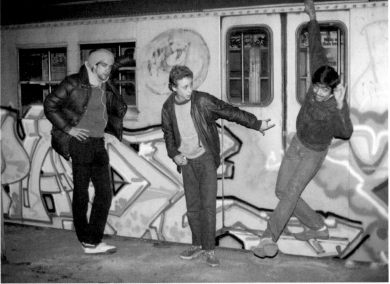

1980, it was even worse. One night, there was the infamous Ball Busters/ TVS fight. Confrontation in the 1 tunnel? There we are—T Kid, Shock, Rin 1, Pade, Rasta, Cos 207, me, and a whole bunch of other dudes. I was about to do a car with Pade and Cos, and T Kid was all the way at the other end. There was a whole line of us, maybe fifteen or twenty in all. Next thing you know, we heard these gunshots go off. The Ball Busters came in, like thirty of them. One of them was popping rounds off, and bullets were hitting parked trains. Everybody just took off. We left like 100 cans of paint there. Then they started coming in the other end. They had us cornered.

Four of us got caught, and they beat the shit out of us. I almost got killed that night. I got hit in the head a couple of times and had concussion. They caught Cos—the president of ROC—who had to have eighteen stitches in the head. They got Boozer, too. The Ball Busters weren't even writers, although their little brothers were. They were the dealers from upstairs. They were psychos, man—crazy. The politics behind it, I'll be honest, had a lot more to do with Shock and Rin. I couldn't tell you what the initial beef was with those dudes. It was just big at one point.

Two weeks later, I'd healed. I wound up going to the "Beyond Words" show at the Mudd Club. A huge gang showed up. They turned out to be the same dudes we had had beef with two weeks earlier. This time I had a pistol, and they knew it. Dudes started pulling guns out of their socks. All of this was going down outside a graffiti show—the first one actually, or at least the one where graffiti took off. They tried to get into the Mudd Club and steal Dondi's Walkman. Freddy and Futura threw a load of chairs down the long staircase and fucked them up.

When the cops showed up, I was out there with Iz, Al Diaz, Bomb 1, Regal 192, and Siko—fresh from fucking the M train—and all these dudes. I ended up talking to the dudes I had been fighting with two weeks earlier, and they were cool. We squashed it—averted the blood bath. We just talked. They were very appreciative that I hadn't pressed charges for what had happened before. "Yo, I ain't no rat," I said. "We take care of our own

shit." It had been a mixed crew of TMT and the Ball Busters down there. TMT: their main dudes were from the Bronx, but all their wannabes and minions were from Harlem, right by the 1 tunnel. Once Ad Rock tried to shoot me and T Kid on the 125th Street platform, in broad daylight. And I'm not talking about Ad Rock from the Beastie Boys... Ad Rock and I were big enemies. We went at it a few times. The last time, he showed up with a pistol and we had to make a hasty retreat.

Our peak years were '79 to '82. In '77, we were just writing on the insides. By '78, we had started to do pieces, and I was just writing Sage. It was around this time that I got the name Bil Rock. My real name is Charles Williams, and my parents always called me Billy. Folks at the Bandshell started calling me Bil Rock. I was hanging with Fuzz a lot, who liked to call me Bil Rock, and it just stuck. So I started doing Bil Rock pieces. By '79, we were all about hitting different lines. We were exploring different places and making alliances with clubs from those places. We made friends on the RR line—guys from the TSS crew. And we made friends from the M yard and with guys who painted the Js—like the CIA dudes.

I'll tell you hands down, Haze has one of my favorite throw-ups. As far as RTW, he has by far the best throw-up. But all our styles—Haze's, Revolt's, Zephyr's, Rasta's, mine—derive from the Upper West Side style, which was originally put together by dudes like Ali and Malta. You've gotta give credit to the original dudes.

Straight up, those peak years for RTW were the golden age of graffiti. So many great writers were active during that period, and you could get away with so many things. We had our own world. We'd go writing four days a week. Oh yeah, man, it was fun in those days. Manhattan was well burned by my time. You had to rack for your paint. I excelled at going to the outer boroughs, where they just weren't as experienced with the thievery. You had to be slick, but we pulled it off. We also had our own economy. We'd sell stuff we'd racked to local bodegas. That's how you'd get your money for your Chinese food, your cheeba, your Ballantine Ale, or whatever. Then you'd go to the lay-up. We drank Ballantine

Ale—the one in the green bottle. I must confess that I was turned onto it by Jean-Michel Basquiat and Al Diaz.

Actually, the only time Jean-Michel ever went to a train yard was with me and Zephyr. We took him to 215th Street, at the top of Manhattan. It was winter, probably '78, and we did the insides. Me and Jean-Michel were wacked out of our brains on peyote, but he'd talked me into it: "Let's go to the yard! Let's go to the yard! Take me to the yard!" I didn't want to go because I was fucked up. I called Zephyr, who was sober, and I was like, "Dude, you gotta take care of us. Take us up to the elevated. I'm fucked up." When we got up there, we bombed the trains—like an entire train, every car on the insides, killed by Samo, Zephyr, and Sage. I wish I had pictures of it.

When it came to the point that you had to step up your knuckle game to survive, that's when graffiti became bullshit to me. I loved the days when it was crazy and mixed up, and the first shows were going down, like the "Times Square Show." Jean-Michel came to me: "Yo, I know these two brothers, man, John Ahearn and Charlie Ahearn. And we got this gig. Come on down. Do a piece." So I went down there and ended up doing the top floor of a staircase—a mural with T Kid, Shock, and Rin. It's funny: we were more interested in saving as much of the paint that John and Charlie had given us as possible, so we could go to the D yard later that night.

There weren't many bad drugs back then. You had psychedelics, weed, and alcohol. It was before crack took hold. Those were the good old days. The lay-ups in Midtown were just the bomb every winter. We didn't even have to go far from our homes, and we could hit all these different lines: D trains, Bs, AAs, RRs. It all happened to coincide with the whole Village, Ramones, Blondie thing—you know, the pre-Fun Gallery days. It was just a blast. Dudes like Jean-Michel hanging out like it was nothing. It was before the vampires got him. He was just Jean-Michel.

To be honest, I was pissed off with Futura, and the whole injection into the gallery scene was looking sour to me. We were about to get totally hoodwinked by art pimps. But I must say that the Esses Studio thing was great.

That was actually more Zephyr and Rasta than Futura; it was only later that Zephyr got Futura to help him, and Futura became the manager of the thing. He didn't even know anybody. He was fresh back from the navy. Because I was really active at the time and knew everyone, they were like, "Yo, bring people." And I was like, "All right." So I first brought Kel and Crash, then Butch 2 and Kase 2, then Tracy 168. Esses, who was a really cool older rich dude, told me straight up that he wanted to put these paintings away and pop them out in twenty years because then they would be worth something. But, you know, eventually I got frustrated by the whole scene and started asking for stuff in writing. I did four paintings there, and I walked out with two of them. The two I left behind are in the Esses collection now.

At this point, around '83, I was starting to get burned on graffiti in general. Between getting shot at by the Ball Busters, and my boy Cos getting his head split open, and dudes cutting me, and having to walk around with a gun, it just wasn't fun anymore. It wasn't the partying and the psychedelic experience that it had been. It just wasn't there anymore.

I joined the army reserves, went away for a while. I came back a couple of times, but I'd pretty much split. I ended up moving upstate to Woodstock and working up there. I became part of the whole Woodstock trip. I was into making money and I didn't see it in the art, even though the Fun Gallery was happening and "Beyond Words" was a success. I just didn't see it getting beyond us being pimped to death. And I was kinda right because what people were getting were some pimp-ass prices.

I didn't reconnect with what was happening with graffiti until around 2006. It was really weird. It was like I was in a whole other world. I was actually working in law enforcement, but somehow I ended up moonlighting as a store detective at Tower Records and they had a magazine—*Can Control* or something like that—that had one of my pieces in it. I was like, "What the fuck is this?" And that was the first time I started looking at this like, "Whoa, what the hell is going on?"

BREEZER

Breezer comes from the same part of the Bronx as masters like Seen and Duster. He is what you might call a "blue-collar" writer because he put in some serious work. And if you weren't from his neighborhood, or if you didn't frequent the main lines he painted, you weren't necessarily familiar with his output (plus the looming shadows of guys like Seen, Duster, and PJay can bring darkness in the middle of a sunshiny day). But it is often guys such as Breezer who have the kind of stories that give you a window into the heartbeat of a kingdom—words that can bridge the gap between the kings and the forgotten worker bees who paint because they want to wear a crown, too.

started writing in '79. I was in a crew in my neighborhood, the Parkchester area of Pelham Bay, in the Bronx. We just sorta picked our names. I came up with Breezer. People started using it as a nickname, and I liked it. The name just stuck. It was the same for a couple of my friends who picked their names: they just stuck. There was never a transition where I went up on the line and changed my name. In fact, Breezer wasn't the easiest name to piece as it has a lot of letters. A lot of people opted for shorter names—three or four letters—so they could get their piece done more quickly.

I did a lot of neighborhood tagging at first and inside bombing, but it got repetitive. Later, I moved on to the outsides. My friend Sin and I would paint together. Our first outside train was on Gun Hill Road, on the 2s and 5s, back in '81. At that time, gangs were undergoing a transition and morphing into crews. There was a reason they could do this so easily: hip hop. Hip hop brought a lot of people together—Hispanic, black, white. But it was graffiti that made it possible for everyone to link up. With graffiti, it didn't matter what color you were.

My family knew I was involved in graffiti. They knew that a lot of the writers weren't white. Me and my friends were mixed, so I never got negative feedback from them. With the earlier, more traditional gangs, there had been distinct ethnic groups. People stuck with their own: you had the black gangs, the Puerto Rican gangs, the white gangs. You couldn't even cross different turfs without getting a beating. When the gangs made way for the multiracial graffiti crews, it was kinda weird to start off with because it was an unknown. But we adapted and, before long, there were people of all colors painting together. As far as we were concerned, everyone was equal.

UA—United Artists—was the main crew I painted with. When you first start writing, you're a neighborhood toy. Nobody goes to a train for the first time and paints a masterpiece. Writers start off as neighborhood kids who meet like-minded guys and start a crew. If there are a hundred crews, fifty of those will be popular—and you want to be down with one of those.

In my early days, I remember playing hooky, taking the train, and looking for masterpieces. I would see names like Lee on the 2s and 5s, and Seen on the 6 train. Comet and Blade were big names, but there were so many writers. Mitch 77 also sticks out in my mind. I grew up around Castle Hill Avenue. Eventually we got together a crew there. That's where I hooked up with Sin, who used to work for Seen, and Dust. It was our stomping ground. We'd make our plans there; that's where we'd go before we racked up the paint and made moves—Seen's place.

At that time, there were squads of police whose sole purpose was to eradicate graffiti. We'd try to stay as far away from the law as possible. A friend of ours used to run the local YMCA, so that's where we'd have our parties; that's where we'd hang out. We'd watch the trains go by, and if we saw something we liked, we'd take a picture of it. Castle Hill station was our spot. Our photographs were nothing like Henry Chalfant's; we used Polaroids and 110 cameras.

Writing graffiti was the best feeling in the world. It's just a rush, everything about it. The scheming to get it all set up, from racking the paint to your heart racing—making sure you got out of that store with the paint. The police had a separate task force assigned to the racking alone. There we were, a bunch of teenagers on the train coming back from downtown with huge paper bags full of paint. We'd go out to more affluent areas because everywhere else the paint was in cages. The store owners could tell what was about to happen as soon as the kids walked in. Sometimes we'd go out to South Jersey and try to fill the trunk up with paint.

Working out a plan—deciding where we were going to paint—was intense. You'd think about the best places to paint in terms of whether the cops were likely to be there; what was hot, and what not. Then there was the smell of the yard, the humming of the train motors, the ducking between cars if you were on the lay-up. Being three or four stories above ground on an elevated lay-up was a particular thrill: we knew that if we were on that catwalk and got chased by cops, we'd have to make a swift

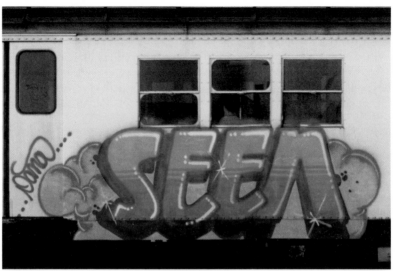

ABOVE Seen UA, 1983.
BELOW Outline by Mitch 77, 1980.

escape—somewhere we were sure the cops wouldn't be waiting for us—so we'd slide down one of the elevated poles.

The feeling of painting a train was great, orgasmic even—the best feeling in the world. It wasn't like doing a wall or sitting in your house doing a canvas. There was a lot of pressure, and always a huge adrenaline rush because you could never get too comfortable. There was no such thing as going to a lay-up and saying you got it like that, because you just never knew what might go down... It didn't matter how good you were, how skinny you were, how fast you were. Nobody was safe. No matter who you were, you had to be careful and keep an eye over your shoulder. You would always hear something unfamiliar. Sounds would often be muffled by humming train motors. There was always a motor running.

There were people hating on who was king and who was not. We had our beef with MPC. That went on for a while. When it came down to crossing paths, blows occasionally had to be drawn. But the 6 yard was ours, without a doubt. Put it this way: only we went in there, no one else. No one dared set foot in there when we were around, unless they knew one of us. There was a lot of crossing out, you know? A lot of slashing. Me, personally? I never got hurt or hurt anybody, but the next day I would see my name crossed out. Whenever dudes did that, they would often leave their name and, you know, keep a low profile for a while. It's not nice to spend a couple of hours doing a car and then see it crossed out or have a throw-up all over it. Cap sorta played a part in that: he just went over everybody. He's much cooler today, but back then he was on a mission to go over everything. He didn't care.

With UA, Seen and Dust were always the leaders, in my eyes. Everybody had a different perspective. Seen might have put more work in over the years, but I always preferred Dust's style; I always thought his work was better. You'd pick up different things from different writers, but it was always nice to have your own style. At the same time, we'd sit in a room and exchange outlines. Or, let's say we were going to do a car: we'd draw up an outline first and, if it caught our imagination, we'd work with

38

it. It all depended on the circumstances. If you felt confident enough to spend a few hours in the yard, you'd give it all you had. But if you thought it was a bit risky—if there was a bad vibe or something—you'd want to get out of there.

From 1982 to '85: those were my most active years—when I was most dedicated to painting. It was all about getting out there and being able to pull something off without getting caught. Who can get the most cans? We spent most of our time on the IRTs, the Lexington Avenue Line. There were other crews on the Broadway Line and we'd see their work. We'd say, "Oh well, guess what? We're going to pull off a car tonight and it's going to look nicer." There was a lot of competition. At that point in my life, it was all about doing what I had to do. Seeing your name run—that was the shit. It wasn't so much about putting your name on a wall; it was about seeing your name roll. You gotta remember, it didn't just stay in one place. The 6 train would run from Pelham Bay to Brooklyn Bridge.

We'd also go to the Ghost Yard, which was famous for having all different types of trains. Some nights we'd go up there and do nothing but bomb. In '83, they started to paint the trains white. That's when graffiti started to die. We knew it was coming to an end. They started leaving dogs in the yard and putting up more fences, but that didn't work. We found holes in the perimeter that provided access into the yard. We would chain up the hole ourselves and had a key, so that it wasn't noticeable. It got really hectic towards the end.

That's when I started phasing out a bit. It kept getting harder and harder to paint. You had to make a whole new level of plans in order to pull off your piece. The authorities started imposing heavier fines and amended the laws. Graffiti became a felony. This crackdown was part of the reason I quit. Then, in '87, my partner Sin died in a motorcycle accident and that put me underground; after that, I was done. I kept in touch with certain people, did a little drawing here and there. But as far as the dedication, I lost touch. I was underground for a long time. I just fell

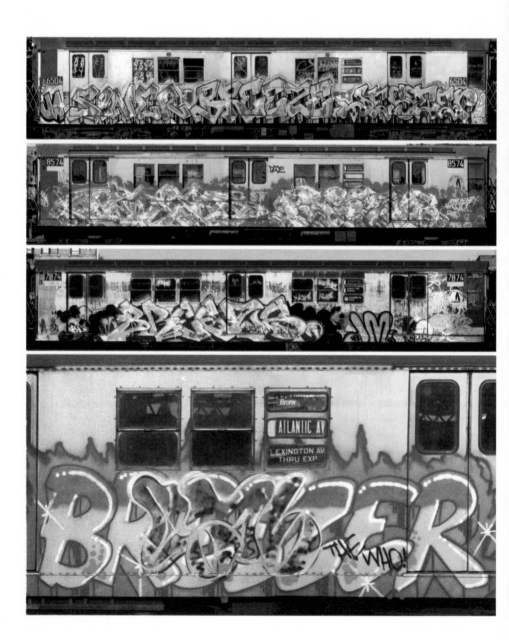

off. Instead of pursuing the art and going in different directions, I just sorta retired.

Recently, through social media, I've reconnected with some of the guys I used to know. I started hooking up with Dust again, who was in California. For a while, I was talking to Seen, who was in Paris. I hadn't spoken to him in years, so it was pretty cool. Nowadays, I paint whenever I have the time. I did some work on canvas and a few jobs on the side, like gates and storefronts around where I live. I do work here and there, but it's not a career choice—not yet, at least. Maybe that will change. I'll see what happens. It's surprising how the culture has evolved.

It seems to me that the new generation of writers has it easier, or at least they have a lot more tools to play with. In my day, the main choices were Krylon or Rust-Oleum. There were other brands, like Martin's Paint, Red Devil, and Wet Look. But only standard caps were available. These days, there seems to be so much paint out there. The paint isn't even the same as it used to be. It's much thicker, and who knows what chemicals there are in it. Still, you can see how far graffiti has come by looking at the products these companies are coming out with—new tools and paint markers, and all these different types of inks.

There were some early writers who got in the galleries years ago, and I see that as a good thing. There's more recognition of graffiti now; it's seen more as art than vandalism. If you can put out good work, show it in a gallery, open people's eyes to it, and potentially sell it, you know what?: more power to you. I don't think there's any reason for anyone to be bitter. I hear a lot of stories about writers from the 1970s—guys with issues. They feel like they were the first generation to write and should be recognized. In these times, with everything that's afforded to you in

FROM TOP TO BOTTOM Siner, Breeze (Breezer), Jester, 1983; 2Bad, Breeze (Breezer), 6 line, 1982; Breeze (Breezer), 1982; Breezer (Cap over).

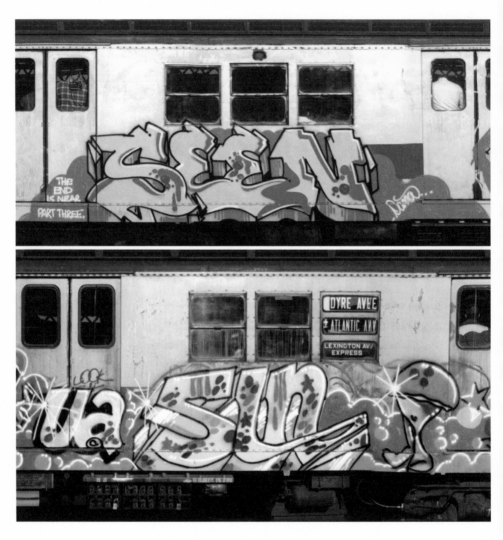

ABOVE Seen UA, 5 Lexington Avenue Express, 1982.
BELOW Sin, 5 Lexington Avenue Express, 1982.

terms of networking, I can't see anybody really having trouble pursuing that dream if that's what they want. You just have to work at it. But if you think you're going to be in a gallery just because you wrote thirty years ago, it's not going to happen.

It was great to grow up in the 1980s, but you can't turn back time. We painted big metal canvases that rolled by. It was a great thrill. Several decades on, it's great to sit back with one of your old crew members and talk over the different experiences you shared. Sometimes it jogs your memory and you're like, "Oh yeah, I remember that." But a lot of times, you find you've forgotten quite a bit. It was definitely a great experience, I gotta say that. I wouldn't change anything about it. Except the fact that they put up the heavy fences.

DAZE

Daze was a comic-book art fan when he was young, and that enthusiasm translated beautifully to his choice of color schemes and bold letter designs. Living on the mysterious Roosevelt Island during some of his formative subway painting years, Daze made a name for himself through the fluidity of his relationships: few writers have the ability to cross over into so many worlds the way Daze has—a skill to which his success in museums and galleries around the globe bears further testament.

I grew up in New York. Until about 1976, I lived in Crown Heights, Brooklyn. Then my family moved to Roosevelt Island. This was a pretty crucial year for me because it was around the time I came into contact with people who were writing on trains. Subway graffiti was something I had been aware of growing up in New York in the 1970s, but up until then it had been a mystery. I was like the average pedestrian: you see it, you think about it, you wonder who did it, and how they did it, and that's about it. But there was something that drew me to that culture because people were expressing themselves in a way I had never seen before. There was more to it than people randomly writing their names on subway cars. It wasn't until 1976 that I saw a car by Blade. These dancing girls were kinda splattered across it. The car was laid up on Utica Avenue, so I got a really good look at it. That triggered my interest in graffiti: seeing that there was something really creative behind it. That's what I wanted to be a part of.

At the High School of Art & Design, there were tons of writers. I got there in 1976 and met guys who were painting, like Don 1, Inca, and Chino Malo. 2Mad went there and, later on, Pink, Seen TC5, and Doze. In the lunchroom, people would pass around black books. The whole black book culture was in full swing there. There were writers who were known for the pieces they did in black books; art school lent itself to that. At some point, I met Dean BYB from Queensbridge, who was up a lot. His whole thing was, "You can't just be a book writer: no one is going to know who you are. You gotta get up, you gotta get your shit up on the trains, you gotta get your feet wet." It really made sense to me. I realized that there were a lot of guys at Art & Design who were never going to take it further than black books, and I didn't want to be one of them.

Dean had two careers: one on the Upper West Side of Manhattan, the other in Queens. On the Upper West Side, he ran with his crew, BYB, and people like Cliff 159. Dean's crew was really an offshoot of 3YB, Cliff's crew. Dean was in the streets doing all kinds of stuff. Then his family moved to the Queensbridge housing projects in Long Island City.

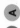

I'm not sure when exactly they moved there, but I think it was around '75. He knew people in Queens KB and all those guys from Astoria, and from the 7 line. He used to work at Goldwater Hospital on Roosevelt Island, and I'd see him making his way to and from work. He had pieces all over the neighborhood and was really well known. I believe he was on some sort of probation and didn't want to get into too much trouble out there. I met him through a guy on Roosevelt Island who knew him from Manhattan and introduced us.

Crown Heights was totally different from Queens. I mean, I had found dead bodies when we were living there. Our home had been burglarized a couple of times. It was a really dangerous place to bring up a family. Roosevelt Island was a new community. The way it was designed, it was divided into three areas by income: low income, where I lived, middle income, and high income. So there was a real mixture of people living there. It was a unique experience growing up there because, in some ways, it was like a small town. The location was also unique, sandwiched between Queens and Manhattan. I had easy access to a lot of different things. I saw what was happening in Queens, Manhattan, the Bronx. I was able to move around freely from there.

I discovered that there was a thriving writing culture. At the Writers' Bench at 149th Street, I met a whole world of writers—guys like Crash, Kid 56, and 2Mad. A whole slew of guys went to the Bench. People didn't have Facebook, email, and all this social networking. At the Bench, I came into contact with writers I had wanted to meet. Once in a while, somebody legendary would stop by—Kase 2, Butch 2, Chain 3, even Comet. That was pretty exciting, but mostly it was about watching pieces go by.

What's missing now, I think, is the element of pressure: you know, the pressure to accomplish something in a short space of time using a medium that is notoriously hard to perfect. Nowadays you have access to writer-friendly spray paint, as well as amazing caps and all that, but we never had that. Your options were really limited, and spray paint was a medium I was trying to figure out. And of course, there are all these different elements

ABOVE Seen TC5, Doze, 1 Broadway Local, 1981.
CENTER Comet, Lexington Avenue Line, 1976.
BELOW Cliff 159 wall, West 96th Street, Manhattan, 1978.

you've got to contend with when you go to the yard. You go there with an outline and you hope to pull something off that's acceptable. Sometimes it happens, sometimes it doesn't. Every time I went to a lay-up, I remember feeling that it was trial and error because I was still trying to figure it out. Up until 1980, it was like that. But by 1980, I really thought that I got this game. I got this locked now.

My parents didn't understand what was happening and never really spoke about it. Because I was spending a lot of time drawing and doing something creative, they didn't seem too worried. The fact that they didn't get the whole picture probably helped, too. When the time came to paint, I just left. Sometimes it was during the day, other times at night. A lot of the time I tried to paint during the day, believe it or not. In New York City, you could often get away with it, you know? My schedule was dictated by the spot I had chosen. Some places were great at night but not during the day.

There was never one particular location that I liked to paint, but I found tunnels a lot more appealing than going to yards. There was something about the environment of being in a tunnel that I still find eerie and mysterious, but attractive at the same time. In a tunnel, you hear tracks clicking, compressors going on and off, water dripping. If something happened, it was easier to hide. You could almost disappear if you had to. I think the darkness, in moments like that, just sharpens your senses. You're able to figure out what colors work best and what you have to do.

I came close to getting caught many times; there were a lot of chases, but I was never actually caught. Writers had the upper hand at that point. Some people may have been busted like once, but it was hard to imagine that it would ever happen to you. I was also really careful about where I went to paint and the situations I got myself into. I would keep my eyes and ears open. You would go to a spot and check it out before doing anything. You let your instincts guide you. Sometimes they would tell you, "Well, this looks good." Sometimes I'd find the doors open and the lights

on. That would tell me that the authorities were watching that place. You knew that either someone had just been chased or they were lying in wait.

I don't come from a rich family. I had no money. Buying paint? Nobody did that. If you did that, you were ostracized immediately. It didn't matter what social background you were from. You just didn't do that. Racking paint was just a part of it. To understand it properly, you have to understand the whole culture of subway writing in the 1970s, which means you really have to understand where New York as a city was. Things like graf were really lightweight compared to the other things that were going on in New York City.

In terms of racking, I would just go all-city—even Jersey. At some point, I realized that, in order to excel as a train writer, you have to build up a stock of paint, so I just concentrated on racking. Then I was like, "Okay, I've got a lot of paint." You go to a lay-up, sometimes you use all your paint, but a lot of times you don't. You have these half-full cans at home, so you rack more paint, and your supply just gets bigger and crazier.

No one could ever lay claim to having showed me the ropes. I learned a lot from going to the Bench and keeping my eyes and ears open. I looked at pieces and took photos. Before I met Henry Chalfant and Martha Cooper, I was taking pictures of my own; I would study pieces and try to figure out styles that way. I practiced in black books. I really admired writers like Blade, but I also liked guys like Fuzz. He had a very readable style, but the way he layered his pieces made them hot. Noc 167, Kase 2, Padre, Mitch 77—there were a lot of people whose work I really liked.

In the beginning, you start out with a name. You try to choose a good one, one that isn't taken. That's one aspect of graf that people today seem to have forgotten: choose something that's original. From there, you jump to tags, signatures. I thought Dean and Don 1 had amazing hand styles, especially Don—not only his style of doing pieces, but also his tag style. There was something about it that was really loose

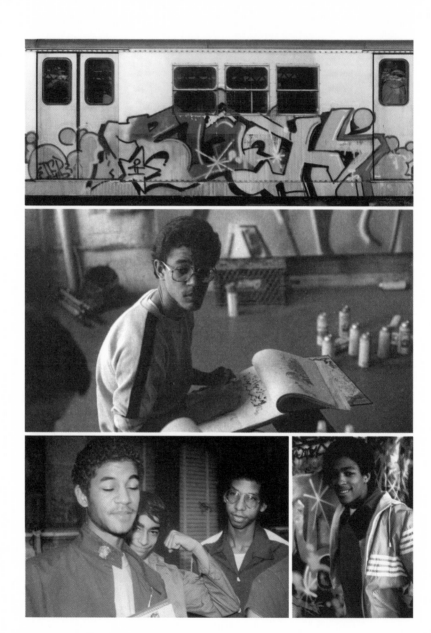

but amazing at the same time. Those two were kinda my role models, in terms of signature.

I found Kase 2's stuff incredibly complex. When he talks about doing his "computer style," it looked like he was really dissecting letters. The first time I met him was at a place called Noga—not the original Noga on the Upper West Side, but the second coming of Noga by Katonah Park. It was run by Jack Pelsinger. I would hang out there. One day, I remember Kase coming by. He sat down next to me and did this amazing piece in my black book, while telling me a story about how he and Butch 2 would paint. I was blown away; I felt privileged to be in the company of people like that.

Looking objectively at my career, I don't feel that I was a king in the same way that someone like Blade was a king, or Tracy 168, or Iz the Wiz, but I painted with just about everybody who was fly during that period. I looked at somebody like Noc 167 as an example. Noc painted with TDS crew. He painted with an assortment of guys, from Mitch 77 to the MG Boys, to guys like Fuzz, to Dondi out in Brooklyn. He really got around and I liked that model. I tried to tailor my career in a similar manner.

My social network was pretty wide. I wasn't looking at graf as a vehicle to beef. I thought of it like, "If you're going to excel at this game, you need to have bridges. You need to be cool with people to sort of get around like that." So that's how I was. It wasn't something that was premeditated; it came quite naturally. At Art & Design, I had known writers from Brooklyn, Queens, the Bronx, Harlem—pretty much all-city. And even when I went to the Bench, although most of the guys there were from the Bronx and Harlem, some were from Brooklyn and Queens.

I don't look at beef as a development; I look at it as a symptom. In the 1970s, there were pretty tough guys in graf, guys you wouldn't want to run

DAZE

ABOVE Butch 2, 1980. CENTER Daze with his black book, Esses Studio, Manhattan, 1980. BELOW LEFT Daze, Rek (Mr. Wiggles), and Nac. BELOW RIGHT Noc 167 at Fashion Moda, Bronx, 1982.

into. They were almost like predators: they would try to take your paint, rip you off, whatever. But I think before the 1980s, the whole scene was more isolated. Nowadays, it's different: if you have beef with a certain member of a crew, then you have beef with the whole crew, and a lot of people are drawn into conflict.

In '83, I started to slow down with the subway painting because, around that time, the white trains were coming out. I remember dudes were busting tags with flooded markers on the outside of trains, and I thought, "This is where it started. Why are dudes doing it that way now?" It made it harder to actually do pieces because you couldn't spray paint over that. In the back of my mind, I thought, "Wow, this is really regressing now." But more importantly, I felt that I had made all the statements I wanted to make. I had painted all I wanted to, with all the people I wanted to, and, you know, life was changing for me.

Initially I wasn't sure of the potential of making paintings or showing in galleries, but at some point that changed. I realized it could lead to something and that I should take it seriously, so I pursued it. During this period, I was still painting on trains a little. I never completely switched from painting on trains to working on canvas; I had a foot in both worlds. My experience with galleries was mixed. I definitely had some exciting moments, but in the beginning there was a lot of disappointment—shows that I wasn't included in and other opportunities that I was passed over for. But I had a long-range game plan and I realized I was going to be in it for the long term. That's how I looked at it. That helped me to get over those disappointments.

My involvement with Fashion Moda was a pivotal point for me because it wasn't really a commercial gallery; it was more an artist-run alternative space that was project-based. There wasn't a commercial pressure to sell,

ABOVE Fashion Moda, 3rd Avenue and 147th Street, Bronx, 1982.
BELOW Wind (Daze), Skeme, 3 yard, Harlem, 1982.

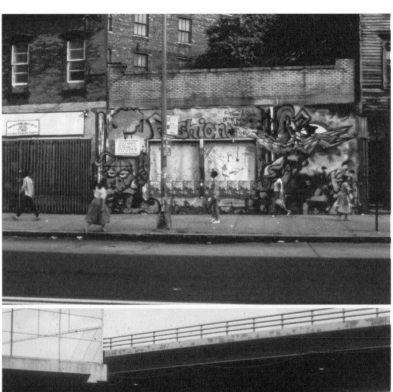

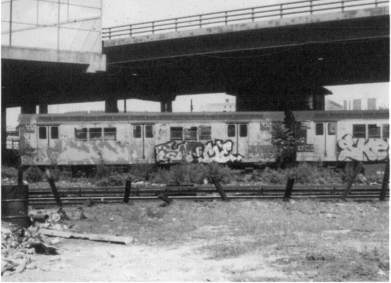

sell, sell, because they were getting funding for the space. And it was really the first space I had showed at where the artists were just left to be artists, to do their own thing. I really liked that. I liked the feeling of having control over what I put up on walls. When I started showing downtown and in Europe, no one ever told me what to paint or influenced what I was painting.

Still, looking back, some people in that gallery world were opportunists. They wanted to control the culture as a whole. But only as long as people were buying the paintings. As soon as that interest dried up, they were gone too. At least that's the way it was in America. In Europe, I felt there were people who had a more long-range interest in the culture, and were better equipped to deal with it. People in America seemed to want to use it for their own gains. I met a million art dealers who talked to me as if I was representing the whole culture. That became a red light for me because I realized that the people who wanted to do that weren't really interested in me as an individual. They were just interested in me because of what I could do for them.

It started to fizzle in the mid-1980s, around '85. I remember coming back from the Basel art fair in Switzerland. I was up there with Crash and A One. I think that, at that point, art dealers and the art world in general had realized that graf wasn't going to be an easy thing for them to capitalize on; that everyone had their own particular personalities; that you had to deal not only with the artwork, but also with the artist.

My first solo show was in 1987, with the gallery Spearstra in Monte Carlo, I believe. It was a great thing to do and remains one of the best experiences I've had to this day as an artist. People there were still interested in graf. I also learned that people were interested in me individually, not just as part of a group. Now, it's bigger than ever, but I don't think it's reached its full potential: it can get even bigger. I see what's going on, the people who are in it just to make a quick buck. There are other people who are just interested in it for the long run. Trying to navigate yourself through that world and work out who's genuine is a really difficult

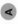

thing to do. Over the years, you have various experiences. You make some mistakes. You learn from your mistakes. But your senses are sharpened through the process.

There are people who have built entire cottage industries around this culture and are earning good money, because they are making products that are geared specifically towards the writers. I think that's pretty amazing. Something else that I'm really optimistic about is that a lot of these manufacturers are looking to perfect their product—whether it's caps or paint—because they know they can make it better. These days, any given brand will have hundreds of different colors and like twenty different shades of the same color, whereas back in my day there were maybe 100 colors and that was it. You had no choice of brand: it was Krylon or nothing. We had to make do with what we had.

Now the spectrum is way open, I think you see that reflected in people's skills. You know, it took me a long time to get comfortable with spray paint—to get to the point where I was in control of it. These days I think you can be out for a few years and pretty much get the hang of it. On the other hand, people may be technically better, but originality has nothing to do with that. Originality comes from some place within; it has nothing to do with technical skill. And I think if you really want to excel, you have to have both. You have to be technically good, but you also need imagination.

I'm not steeped in illegal graffiti and I haven't been for years and years, but I feel that the perspective of a writer who is beginning now has also changed. There are a lot of people who start out now with the expectation that everything should be gifted to them right away. The definition of "keeping it real" has evolved. For some people, keeping it real means never doing a professional wall. It varies now; it's not just one thing.

Car number 8978 (p. 56, top): I remember doing that car with Kel and Nac. Nac was a guy I was putting on; I was showing him the ropes. He eventually got good on his own. That piece was a good example of what I was trying to do stylistically because the outline was pretty simple, but I

FROM TOP TO BOTTOM Nac, Daze, 2 Seventh Avenue Express, 1981; Daze, 1 Broadway Local, 1982; Jae (2Mad), 1 Broadway Local, 1979; Trap, Dez, Daze, 1983.

was trying to layer designs in a similar way to Fuzz. He would drop a shine here and a shine there; I feel like I was kinda doing what he was doing. The character is a typical character with ski goggles and an Afro. A lot of people did versions of that character. I remember thinking that it was easy to draw and that's why it was so common. There's a gangster guy in the middle. I was never too much into copying characters, so I always sort of made up my own weird characters.

CYA is written on the car. CYA pretty much started at Art & Design, back when I was hanging out with 2Mad; he and I were really best friends. At some point, he was like, "Yo, we gotta start a crew. Everyone's got a crew. We need to start one." 2Mad was from the Upper West Side and he knew Jean 13, who was from Washington Heights; those guys hung out a lot as well. So we got together this crew—Crazy Young Artists—pretty much in the lunchroom at Art & Design and started putting it up. It wasn't a big crew and it wasn't really something I took seriously. As far as my name, for whatever reason there weren't a lot of people with the letter "d" in their names at that time, so that made it a little more unique and attractive to me. The other letters—the "z," the "a," the "e"—I could draw pretty well. So I just put it together and it stuck.

One of my favorite pieces ever was the Trap/Dez/Daze car. A lot of people I've spoken to have told me that it's one of their favorite pieces, too. I remember doing it one January, on Martin Luther King's birthday. It was pretty cold out. We were in a tunnel painting. Crash was in the car doing his own thing. When I look at this piece and the colors I chose, I was definitely thinking about TFP. I noticed those guys always had black backgrounds and black clouds in everything they did. I wasn't trying to copy them in any way, but at the same time I wanted to try things that I hadn't done before. The outline was a baby blue and I wanted the fill-in colors to be real warm or hot, so I used sunset orange and colors like hot pink that really contrasted. Putting black behind the outline really made it pop. I was very happy with that piece. I remember coming away feeling like I had really accomplished something.

JON ONE

Jon One was always a little different, a characteristic that was reflected in his work on the subways. His Jon throw-ups, rather stunningly, looked like gloriously confident, reclining elephants with rolls of fat. And the masterpieces he painted with partner Kyle reflected on shoddy politics and the side effects of angel dust. In the late 1980s, when the graffiti lifestyle became too much for him, Jon packed his green army duffel bag and moved to Paris, playing an active role in the aerosol renaissance that unfolded there.

My earliest memories of graffiti would probably be Tracy 168 and Ban 2. Ban 2 had a tag in my building so, you know, that was kind of strange. Tracy 168 had a piece on a bar up in Riverdale: it featured a cowboy scene and whatnot, and I always wondered who had done it and how they'd done it with a spray can. It was the end of the 1970s—'78, or something like that. Even before then, I remember seeing CC 153 and Fats 153, who were neighborhood writers. They came out in that book, *The Faith of Graffiti*. And then there was also this guy called Wheat—Wheat TNS and Frane TNS, and also Doze, who lived around my neighborhood.

I never paid too much attention at high school and would sit on the train bored stiff. Instead of reading the newspaper, I would look around and read the writing on the trains: tags by Quik, Zephyr, Rasta, Mackie, SE 3, Futura. It felt like these guys had brands. The way Zephyr used to end his "R" or the distinctive style of Futura's tags... I used to imitate their tags. Imitate, imitate, imitate. I used to fill up my notebooks and schoolbooks with their tags.

Since I didn't really know anyone and I was a big time duck, I started hanging out on the corner of 156th Street. I would get high, smoking blunts and stuff like that, with the neighborhood tecatos. A tecato is a druggy who's also a little bit of a "crimey" type. That's who Wheat I was. He was like a runaway, getting high and riding the trains. The trains were sort of like a playground for us.

Sometimes I would take the 1 train from my neighborhood and ride the first car all the way to the South Ferry, and then back again. I would catch motion tags at the same time. I would take my tag with a marker. I was king of the subway maps, but they could erase that stuff right away. I was king of the windows, too. My tags weren't really lasting very long, so I had to get introduced to the subway tunnels. They scared me. They were like a no man's land. And there were all these rumors about the Ball Busters, especially on 137th Street, and me being a duck... I was Dominican, of course, but not that kind of Dominican, so I was scared to go there, you know?

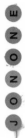

One day, I was hanging out with my boy, Wheat 1, and we got a bag of weed or coke or dust, or some shit like that, and went inside 145th to the tunnel to smoke and write our names. It gave me a hard on. I was like, "Yo, this shit is *me*. This is my life. This is my future." I felt power. I felt like Superman. I felt like there were these two parallel worlds: there was the world where you tried to succeed in life—accumulating wealth or pursuing the American Dream of having a house and a car and being Mr. Jon Doe—and here I was, Jon One, which was something completely different, on an artistic adventure. Having a voice is having a power, so for me that was more fulfilling than anything else I had been doing or seeing or aiming for. Communication is very important for me.

I have a very addictive personality. I don't know what it is; it's something inside me. So I used to tire out my partners very, very easily. Wheat was good for a while, for bombing the insides and that kind of thing. He gave me the hand style technique, which came from looking at Ban 2 and having that flow. These days you get the flow from looking on the internet, but back then learning the flow meant a lot. You can't really learn it remotely, on your computer: you have to be hanging out.

I also hung out with Flite TDS for a while. He broke down the art of piecing: you put up the outline, fill it in, do the background, do a couple of characters, then BOOM! He helped me a lot. He was so much tougher than me. He would do my outlines, I'd fill it in, and then he'd do my final outline. But I slowly tired him out, too. I remember one time I went to see him on a Sunday morning, around 8 a.m. I had a bag full of paint and I was like, "Yo, let's go bombing, let's go bombing." He looked at me as if I was crazy. Flite had a girlfriend and I didn't. The way he looked at me, he was saying: "Get a life. Do something with your life, and leave me alone!" This was around '82, '83.

That's when I started to piece a little bit by myself. I also started going to the Bronx and hanging out with Rac 7. Rac 7 introduced me to T Kid and all those guys up there, which was cool for a little while—hanging up in the Bronx, where the people were fresh. I did a lot of pieces with

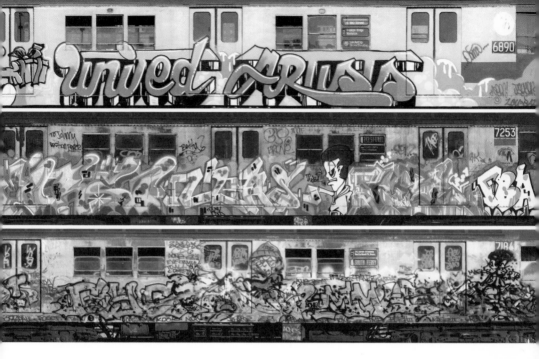

FROM TOP TO BOTTOM *United Artists* by Seen UA, 1982; Flite, Alia, Kaze, 1 Broadway Local, 1982; *Eye Jammie* by A One, *ca.* 1983.

Rac 7. We pulled off production after production after production. At the same time, Rac 7 had a girlfriend and responsibilities. But the urges I had were so powerful. So from Rac, I eventually started to piece with Kyle, whom I'd met at some sort of youth center on Franklin Street for kids in gangs. Kyle used to do the little pieces. He was from Queens and was a good draftsman. We used to gas each other up. We had a simple aim: we wanted to do ten whole cars like Lee had done. But we were never able to accomplish that. We only ever did three and a half cars on one train.

With Kyle, I pulled off a lot of productions with different themes. It wasn't the typical piecing where you have, you know, your name in the middle flanked by B-boy characters on both sides. A lot of the themes were political. We did a *Dump Koch* one time. On another occasion, we

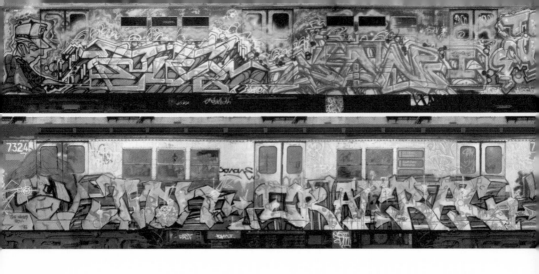

did a *Free South Africa and Central America* car. We also did a roach car—*Kill Roaches*, or something like that. So I guess we changed the format a bit. Writers were working with a rectangular format, as far as the profile of the train, but we used it in a whole different way. I think that kinda freaked people out 'cause everybody was into the traditional style of graffiti. We were flipping it. I was also doing abstract, colorful pieces. There were only a few of us doing the abstract style—people like Phase 2, Delta 2, and A One.

I surrounded myself with a lot of different people. I had a curiosity and openness that meant I didn't want to be confined to one thing. I was going all over the place. And in my opinion, each ethnic group had a very particular style. The whites were painting a certain style, the Hispanics another. With the whites, it was like you were getting a tattoo at Coney Island—very flashy, very well executed. They reminded me of those air-brushed T-shirts you get. They catch your eye right away. With Seen, it's like S-E-E-N. BOOM! You have yellow, orange, Fred Flintstone on one side of the car and Barney Rubble on the other, holding a bat. To me, that's the epitome of white style. It's very flashy, but on the inside there's nothing. It's just flat. There's no soul to it.

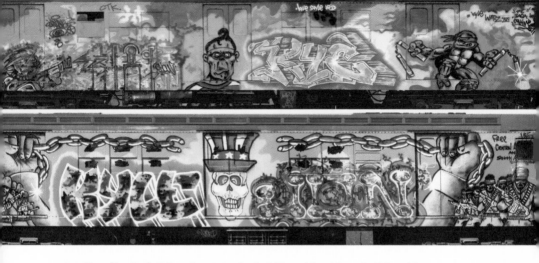

ABOVE Chow (Jon One), Kyle, 1983; **BELOW** *Free South Africa and Central America* by Kyle and Jon One, 1983; **OPPOSITE ABOVE** Flite, Jon I, 1981; **OPPOSITE BELOW** Jon, Era, Rac 7, 1 Broadway Local, 1982.

Now the Latino style is very slick. The FBA style reminds me of *Saturday Night Fever*: you've got the hair slicked back and you have the moves. It's slick, but maybe a little bit too slick. There is no room for error. It looks good, but it's too perfect. It doesn't really represent life. The black style—guys like A One and Skeme—is very rough. Sometimes lines don't meet. Sometimes you have overspray and it's very dirty, but at the same time it doesn't have to be clean in the way that other people rocked it because it has soul. It feels like something a jazz musician might create, like Ornette Coleman, Miles Davis, or Charlie Parker; something that comes from deep suffering. These were the three main ethnic groups painting in New York. Truth is, New York was very separated at that time, so the fact I was hanging out with all these different types of people really broadened my influences. It pushed me not to have one particular style but to…just be a freak.

I had also become known for my throw-ups. I had seen what Iz the Wiz and Quik and Min were doing: how they were using the rectangular space and flipping it, not just staying in the context of a confined space but using all the space. Their bombing techniques had evolved. They took over, especially Min. The way he was filling in, it was just the simple mist. It was just

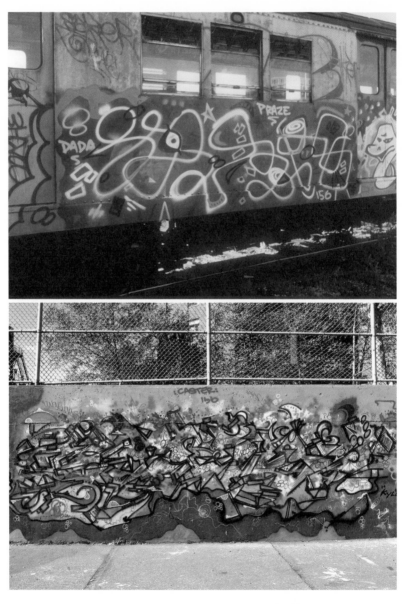

ABOVE *Dada* by Jon One, 1983. **BELOW** Jon One, Graffiti Hall of Fame,
East 106th Street and Park Avenue, Harlem, 1984.

enough, it wasn't wasting paint, and it was always evenly spread with that fat cap. The fill-ins alone were like a work of art, even the outlines.

I remember Min had gone over one of my cars, a piece on the A line. So I had caught a brand new Min piece, a top-to-bottom, in the Ghost Yard. I was like, "Fuck it!" It was brand new, it probably hadn't even pulled out yet, and I just did a throw-up all over it. A J-O-N throw-up.

In a way it was a declaration of war, but it was also just how things were at that time. If you wanted to get attention, you had to get respect and you had to go over people. Sometimes, by doing a throw-up or kicking a piece—just touching the side of somebody else's piece—you felt like a bird spreading its wings. These were the techniques that were influencing me with the throw-ups, and I did a lot of them.

Everybody wanted to fuck me up. Everybody. Because if you fucked me up, you got extra points in graffiti. It was like playing *Pac-Man* or *Space Invaders*. If you fucked me up, word spread that you had had a fight with Jon. It was just as good an advertisement as doing a piece on a rooftop or anything like that. The word spread out: "Yo, I punched Jon's face. I write Spicter." "Spicter" was then on the scene because he had punched Jon's face.

For instance, 2 New, a guy in MSK crew, came up to me while I was rolling a joint. I was lighting it up when I saw this Dominican kid—I didn't even know he was Dominican—just coming up to me like he was just coming up to me, so I knew he was gonna want to throw down. So I said, "Fuck it!" I threw my joint and got into a fighting stance. I took his hood, then he took me by the legs and slammed me on the floor. He put his foot on me and was just like bam, bam, bam, bam, bam. He was just punching. I had braces on my teeth and everything was falling out. The guy who saved my ass was James Top. He was like, "This is enough, man." Everybody else was just taking pictures and laughing. That's how graffiti is. 2 New, by fucking me up, got some extra points. He got respect in the game.

Eighty-five percent of the people who were doing graffiti back then were like tourists. I knew the cycle of the graffiti writer was only about

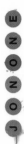

six months. So in six months, there would be somebody else. There were very few who stayed the distance. And there was always somebody new. Towards the end, there was this other crew on 175th that wanted to mess me up—FK...I forget the name. Some Dominican guys. They wanted to beat me up. But luckily, I got out of the game just in time.

I never really slowed down with trains—I just left. I saw these new trains coming out and the whole scene was changing. I saw Ken Swift on 96th Street and to me he was the ultimate B-boy. Then I clocked him wearing a suit and tie, going to work on Wall Street. This was '86/'87. The ultimate B-boy, in a suit and tie, going downtown to work. I felt like something was happening with hip hop. And I was basically burnt out because it was a high-paced lifestyle, the graffiti lifestyle. I don't have any regrets about it, though. I think that graffiti is what made things change in this world. I don't look at it as an act of vandalism.

I could tell things were about to change. I was lucky enough to have a style that some writers in Europe were digging. Bando and all these European guys who had seen my stuff on the trains had been talking about it in Paris, like, "Yo, there's this guy, Jon One, he does some crazy shit. We must contact him!" So they contacted me. Back then, it wasn't like, how do you find somebody's email? There was a network. Someone in the network gave out my number. One day I got this phone call. A guy with a French accent said, "Hello, my name is Philippe. I come from France. I would like to meet you." And I was like, "France? What the...?" "Yes, we do graffitis in France." I was like, "Yeah? What the fuck for?"

I met these guys so that they could buy me some weed and beer. I told them to meet me on 86th Street, at the back of the number 1 train. I met Shoe, Sign, Sneak, and some other French graffiti writers. And they were all dressed fresh—real expensive stuff. They all looked like they had come back from the Swiss Alps and I looked like I had just come back from 125th Street. My face was melting. I was like, "Yo, what's up, what's up? Let's go get high." "We don't get high." I was like, "But I do."

I got some shit to get high. And I was like, "Don't ever do this, it's too good," coughing all the way. They were like, "He's crazy, he's crazy!"

I took them to the yards and 175th. I showed them a good time. We did some pieces. I liked their vibe. And they showed me what they had been doing. It blew my mind. They showed me what Mode 2 was doing; they were influenced by Japanese manga, and the composition of their colors was really cool. Even the spray cans they were using. I was like, "These ain't Krylons..." Anyway, they were like, "Yeah, come to Paris. We can do some pieces." It was a little bit like skateboarding: you wanna skate in Barcelona, you wanna skate in France, along the Champs-Élysées or the Trocadéro—all over the place. I went there and Mode 2 picked me up at the airport.

I was excited to travel to France. You've got to understand, I had invested so much time and effort and sacrifice into all of this and everybody was telling me the same bullshit: "You should go back to fuckin' school, Jon. You're wasting your time, Jon. Why don't you get serious, Jon? What's wrong with you?" I'm very hard-headed, so I was like, "Nah, I'm gonna do this. I've gotta find a way to flip it." I was looking for the next level. I knew it existed. I knew it was out there.

The more you invest in it, the more it will take you to another space in your brain. It may not bring financial wealth or financial means; it may just be a spiritual peace you get. I knew there was something; I just had to push the door a little bit more. Luckily I had this opportunity to leave New York, which was suppressive towards artists at the time, especially graffiti writers. This was like '86/'87. Crazy Legs and the whole break-dancing thing was dead. That's why Ken Swift had to get a job and Crazy Legs worked in a gym. In Paris, I stumbled upon a scene that was being born. It felt like New York in the early 1980s, when Roxy was happening. I was able to witness the scene being born twice: the first time in New York, and the second in Paris. Paris had become the capital of graffiti because the European style masters—Bando and Mode 2—were living there. A lot of the graffiti was based on Bando's style.

Loomit from Germany started coming to Paris to paint. There wasn't really any graffiti in Spain or Italy—a little bit, but not very much. Nothing to talk about. And so it was just Germany, the Netherlands, and England—all the stars from those countries came to paint in Paris.

When I landed in Paris, I had no money and I didn't have my papers. So I lived at this girl's house, where I didn't have to pay rent. I was able to paint in squats, abandoned buildings. Living in that manner, I was able to evolve as an artist. From there, I met one collector—Agnes B—who supported my work for a couple of years.

I wasn't the only American out there trying to make it. A One was doing it before me. He was like a road buddy. Eventually Sharp came too. The way I look at it, it was kinda like when so many American jazz musicians sought exile in Europe; or writers like Henry Miller, who went there because they felt oppressed in the United States. I also felt oppressed in the United States. Paris made me feel freer and more inspired.

Today, the 156 crew is international. We've got Psyckoze: he's the King of the Catacombs, the underground thing in Paris. Kyle is still around. I'm totally surprised because when 156 started, I was such a toy and they had all these crews like 3YB, TFA, RTW, and it felt like to be a member of those crews was harder than getting a job at Microsoft or Google. And if you weren't down with those crews, you were considered a duck. So what was I gonna do? You know? Then again, I didn't really start a crew. I put 156 to say I came from 156th Street. But I had developed a style of killing shit. You know, like JA—a really aggressive type of graffiti. Wanting to destroy something—just throwing paint, painting on seats. It's this aggressiveness I had in me that people caught on to. People started saying they wanted to be part of 156, and I was like, "Yeah! You can be down." The crew went on to symbolize my spirit, which is freestyle. There's no real structure involved, but there is a structure involved. That's what I wanted to be: sort of freestyle.

When I started to do graffiti, I did it because I was seeking freedom. I wanted to do something completely different from what I was feeling inside of the American system: this oppression that makes you talk a

certain way. It was a pain in the ass. I would go some places and have to talk white: "Hi, how you doin'?" And then around my neighborhood, you can't talk white around the homeboys. You'd get slapped.

Freestyle gave me a certain liberty that I hadn't found in this system— the system that made you go to school, do this, do that. I was like, "Goddamn!" "You have to comb your hair, Jon," my mother would say, "or you can't go outside." Or if I had a little splash of paint on me: "That's no good. You'll never get a job like that. Look at your cousins, look at your neighbors, see how they are."

So I tried to look for it in graffiti, but once I got into graffiti, it was also very coded. You had to construct letters a certain way or else it wasn't considered graffiti. You had to write your name a certain way, you had to dress a certain way, you had to act like hard rock. But I just wanted to be free. I just wanted to paint and paint whatever the fuck I wanted.

With graffiti today, I think a lot of it is about people making money. Some people are making a lot of money and I can't see it stopping. They're doing products—companies are using them to promote their labels, to promote their products. It has become a business. The game has completely changed from the culture I came from—a culture that felt oppressed and wanted to revolt. And I don't feel like there's a big revolt. You can't really revolt, especially in the United States, or you'll get two years in jail. So there are a lot of comedians, actors, out there doing their thing.

Luckily for me—me, me, me, me, me—I'm able to survive. Sometimes I look at myself because I can only talk for myself. In France, I have been spoiled silly. I've been able to stay the way I am without having to make big concessions. I'm not really corporate, I have no book, I have no web-sites. I'm still a bit of an underground figure. Nobody really knows what I'm doing or where I'm going next. So I'm able to maintain the roots of what I am—that underground feeling, that homemade, using-my-hands-to-make-money feel.

Kel's reputation for not taking any crap is a distant second to his radically innovative style. His use of silver created a seamless relationship between letter and train car, while the way he employed highlights gave his work the kind of jump that would make you lean back when one of his cars pulled into the station. He was one of the rare writers who had the ability to paint with a diverse range of groups. His productions were so funky that even his enemies respected him. Kel, who rarely talks about his own history as a writer, is a man known more for his work with words than his way with words.

I grew up in the South Bronx, and my initial exposure to graffiti was traveling on the 6 train from my home to Manhattan. The very first graf I noticed was the big "Mini" tag from Iz the Wiz. It was the first to make an impression on me: walking into the train and seeing this fat, draping tag plastered across the headlines in mixed inks—blue and red, or black and red, or green and black. I was like, "Wow!" The impact of seeing this beautiful handwriting really solidified my whole experience. I thought, "I wanna be that." It was 1976. I had seen graf before, but that was the moment it became clear to me—when I was 12 years old.

I remember going to the yard for the first time. The biggest thrill was taking a train all the way up to Westchester Square and then weaving through all the auto parts and junkyard shops, reaching the fence, climbing down into the yard, and listening to the sounds. Every sound in the yard makes your heart pump faster because you don't know what's coming. It's not just the sound of the trains. It's the sound of the traffic around you. Of course, you're stepping on cans of spent paint, chains, and paper, and making all sorts of noise just getting to the hole to get into the yard. Then the fence itself makes a noise. You're touching everything, you're feeling everything, and you're nervous as hell. Definitely a high, without even being a high. And once you're in the car, it's warm. There's the smell of the new ink. This first time, we just did some quick tags and left. We only did two or three cars, but it ignited a passion for sneaking into yards to tag and paint trains. It was an unbelievable moment for me.

After that, I convinced my brother and my cousin, who were my first two partners in this whole thing, to go back to the 6 yard to attempt to paint a train. Of course, none of us could reach the train, which was pretty funny. We'd try to find a milk crate or something to stand on and then paint whatever we did at that point. When I saw it run the following day, it was pathetic: we had barely reached the middle of the train, and it was sloppy. But that's how everyone starts out. You don't quite understand the scale or how to use the tools. You don't have the skill. Then you start to see elaborate pieces with complex lettering by writers like Part.

And you're like, "Fuck, how did he do that?" Then you see writers like Blade and the Fabulous Five. It opens up a whole new world for you. I started to become more aware of graf. I started to get familiar with the 1 and 2 trains.

I started out with names that were typical of the day, like Craze, Jade...I forget the others. But the name Kel came really quickly because I used to eat Kellogg's Corn Flakes all the time, so it was an early favorite. Writing culture was a fairly easy thing to encounter because the kids in my public school were all trying to tag their name on their bag, or their desk, or their school books—so my classmates were a source of inspiration. I asked them how to get paint and markers. "Markers? At an art store in the Bronx. Spray paint? You gotta grab it from a paint shop." Stealing paint was such a high-level, advanced activity that I couldn't imagine ever getting to that point. I felt lucky enough to get a marker.

At the time, the Writers' Bench was the place to be. And all the writers were right there, in the Bronx at Grand Concourse. This kid said, "Hey, you wanna meet writers? Just go there and sit and watch trains, and someone will come up to you and ask you what you write." And he was right. It happened. I was a faithful visitor every day after school, two or three times a day, 365 days a year. There were so many writers at the Bench—easily fifty or so, at any given time. Often there were more writers there than there were passengers on the platform. The Bench attracted the who's who of the graf community. You'd also get guys who were just eager or hungry to claim their spot in the sun. And you had those really young kids who didn't know who was who. They were just toys. They'd walk around with their markers being like, "Yo, what you write? Tag up my book. Let's go do this, let's go do that."

So there was a lot of networking at the Bench. It was probably the first social network for you as a writer. If the train was about to pull up,

ABOVE Part, 1982. CENTER Kel 139, 1979. BELOW Kid 56, 1979.

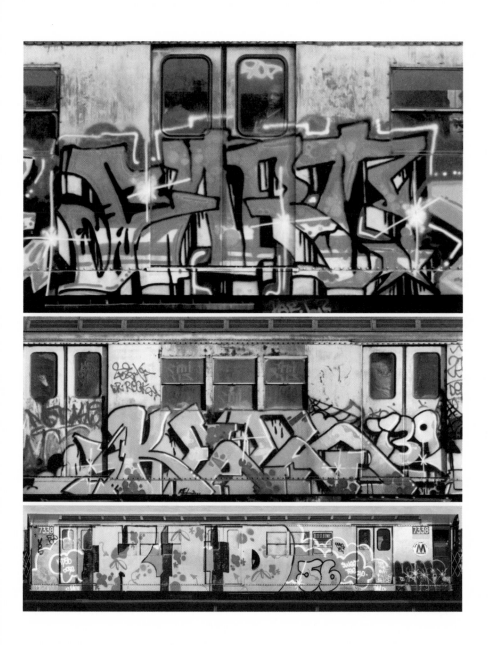

it wasn't uncommon for somebody to pull out a fat marker and just tag on the side of the train. That was the environment. But there was definitely a different type of intensity there, too. Typically, if someone had beef, it was going down. It was a very uneasy moment for everybody because it would bring more attention from the Transit Authority and police. The added layer of tension made it uncomfortable, but it was normal: whoever has beef, let them figure it out.

I tried out the 6 yard a couple of times, but I knew deep down that it wasn't for me. But then I tried the lay-up, which was much better suited to me. The 6 train was just okay. It wasn't until I met Kid 56 that I really started to explore more of the city and build more of a momentum—teaming up with people and venturing out to foreign neighborhoods, racking paint, really going for the gusto. Because his brother was FTD 56—a bigger, old-school name—he had clout. It allowed him to travel freely without coming up against any problems. When he and I became good buddies, it was natural for me to be accepted. Wherever he ventured, I ventured too. Soon, I acquired the confidence to venture out on my own, wherever I wanted. I was like, "I could do this myself and meet some people." I developed a sense of what I wanted to do and who I wanted to be.

The lay-ups provided a degree of "escapability." We could operate more in stealth mode. I felt like there was an angle over the Transit Authority, and we were looking down on them, because they were afraid to run down the tracks. We raced down tracks, slid down or climbed up poles. I did pretty crazy stuff to escape or enter. And nine times out of ten, the cops were pretty fearful of that.

We painted in yards, but I was always uneasy with it because I hated having to look over my shoulder the whole time. You had to crawl in trains to hide from people. It's no fun: you're cramped and dirty, and it smells. But with a lay-up, you only have one train. There could be like twenty cars, but you know what? I didn't have enough time to do three hundred cars per night, but I could definitely do twenty. So it was better

suited to me and accommodated my schedule. I didn't want to be in the yard that late. I wanted to get in on the earlier side and get out of there.

I'd typically try to paint after dinner. My mom would cook around 6 or 7 o'clock. Right after dinner, I'd be out the door. Between 8.30 and 9 p.m., a transit worker would go through the whole lay-up. By 10, he would have finished cleaning and collecting the garbage. Then the train would just sit there until the morning. I'd usually be in there for 10 p.m. and out of there by midnight or just after. In a yard, it's a little trickier. You kinda have to play it differently. Go a little bit later. I honestly didn't have that liberty, and that was the big issue. I couldn't just tell my mom that I was leaving at 9 to paint. But if I left right after dinner, that was acceptable. It was still early enough to go out.

My mom was definitely aware of my work. She eventually realized that I'd probably get into a lot of trouble, and that I was doing a lot of damage, as she put it. I was never allowed to keep paint or markers in the house, so she never saw that side of it. Plus I couldn't justify to her how I got markers or ink or paint. And I couldn't just say, "Oh Mom, I just racked it up." She'd be like, "What is that?" We didn't have extra money to buy that stuff. But black books I could kinda slip in there and be like, "They're just books." I used to send my Kodak film to be processed through the post and get my pictures delivered to the house. That's how my mom found out what was happening. She'd open the mail and be like, "Wow, look at that." She'd be on the trains and recognize my work from the pictures. I think a part of her found it exciting, seeing her son's paintings on the trains. But the excitement was also tinged with fear—she was scared of the danger. Graffiti split people down the middle: they were either in awe of it or just hating it. But either way, they were responding to it.

I was always really interested in being creative. I was a pretty creative child, making up stories, writing, putting together toys to play with, or drawing stuff. There was always that element to me, but graf just ignited it a little bit more. I found it a more attractive, more accessible form. I didn't have to construct something or create a book. I could create something a

little bit more simplified and it would get out there. That facet became really addictive because I would just focus on creating the tag and getting it up. And the more I got up, the stronger the addiction became.

Maybe obsession is a better word. I don't think it was an addiction. Addiction has negative connotations. But I think obsession is good. Because it became an obsession. I'd spend a large portion of my time—when I was supposed to be reading Shakespeare or something—planning out whole cars. I still managed to get my homework done—that wasn't compromised. I had a very strong interest in my education, mainly because my family put such an emphasis on it.

My graffiti education intensified. You didn't just wing racking. It was a skill you acquired growing up in the 'hood. But, more than that, it was essential in order for you to do what you needed to do. It doesn't have to be paint. It could be a toy, books, school supplies, snacks at the store. It's one of those acts that virtually everyone does as a kid. But it kinda takes hold of people in different ways at different stages. And then as you develop, as with any type of obsession, it can become a driving force: "I really need twenty paint cans to cover that train top to bottom." Me? I had paint everywhere: on the street, in my aunt's house, pretty much anywhere I could get to with ease when I needed to.

After a while, being a part of an existing crew became…boring. It was more interesting to be part of a new thing and bring up an era of change. Basically, we were building brands. That's how the whole Roc Stars thing came about. It was like, "Roc is cool, but this is Roc Stars." Aside from myself, Shy and Cos were the two main components. Daze, too: he went to the High School of Art & Design and was a really good artist. Daze was more art-centric, from what I remember, but really talented—could draw his ass off. He had a different sense of creation that comes from a formal

Original outline from Kel's sketchbook for *Production #7*, painted on January 27, 1979.

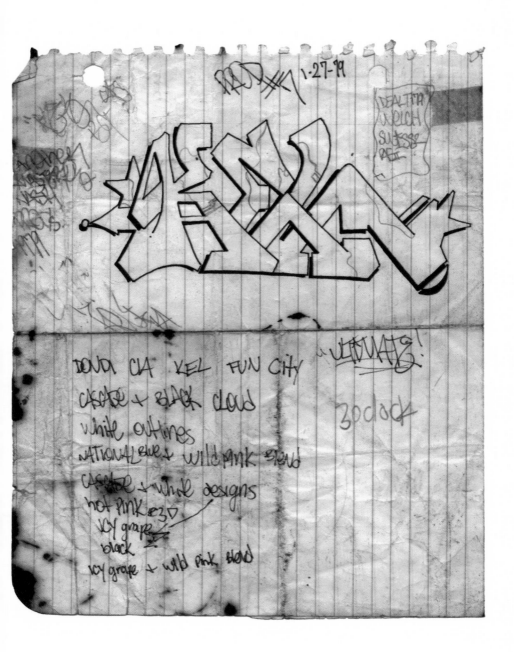

DONDA CIA KEL FUN CITY "ULTIMATE!

CASCADE + BLACK CLOUD

white outlines 3o'clock

NATIONAL blue + wild pink blend

CASCADE + white designs

hot pink e30

icy grape

black

icy grape + wild pink blend

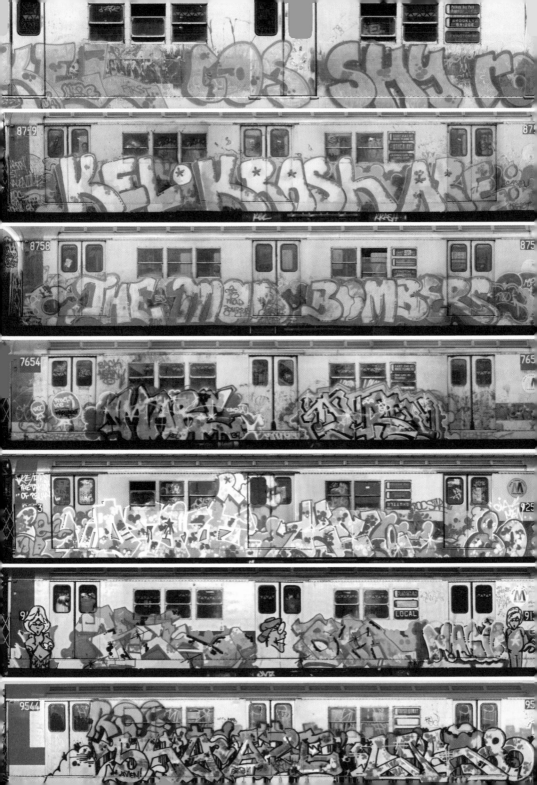

training in the arts. I didn't have that, and neither did Shy or Cos. (As an aside, Cos was a real gentleman; a real fresh cat in my life. He married my sister and they have a son who's really talented.)

For me, graf is more than just writing your name. It's about owning a word that has a meaning—a meaning that you, the writer, make bigger and stronger. I paid attention to that. What does the word mean in the dictionary? How is it used in a sentence? What impression does it give when you say it? Does it sound bold? Does it sound like it's going to kick your fucking ass? Does it sound like it's going to be stomped over? I wanted a name that had some presence and a personality of its own, but was also flexible enough for me to impose my will on it and mold it. If I couldn't do that, then I didn't want to write that name. If it's a corny ass name, kick it to the next guy.

Crash loosely created a crew called Mandate, but I forget what it stood for. It was a short-lived idea that really became the jump off for Roc Stars because I was like, "Okay, this name is not strong enough. I need a bigger presence than this." I guess that was when Crash and I started to drift apart. He started to get more into being a commercial artist or a gallery artist, which is cool, but it's just not what I wanted to be. I wanted to be on the train. I wanted to have my name on every train in New York City. I needed a crew name that had a little bit more substance. And that's how Roc Stars came about.

I think that's why I hopped around from clique to clique: I needed more stimulation from an outlet. A bigger outlet. And every crew that I connected with gave me an outlet that was very sizeable, each one bigger than the next. That's where the appeal lay for me. Like, I'd be all over Brooklyn for a while. I crushed Canarsie Yard. I crushed all over. Then

FROM TOP TO BOTTOM Kel, Cos, Shy, 6 Lexington Avenue Local, 1980; *Kel and Crash are the Mad Bombers* by Kel and Crash, 5 Lexington Avenue Express, 1980; *Kel and Crash are the Mad Bombers* by Kel and Crash, 5 Lexington Avenue Express, 1980; Mare, Duro, 2 Seventh Avenue Express, 1981; Dealt, Kel, 1980; Kel, Shy, 1982; Shy, Aze, Cos, 1 Broadway Local, 1980.

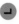

I'd come back to the Bronx and crush the Bronx. That way, it just became bigger and bigger. It was almost like a crusade that picked up momentum as it grew. Eventually, it just died down. I realized that I needed to do something else with my energy. Focusing on a crew was one way to do that.

Not everyone will blend, but I didn't want to create the chaotic, adversarial type of environment that is typical of many crews. I wanted to be more inclusive and for everybody to feed off each other. We were creating this microcosm that I wanted to grow and become a substantial thing. That's where I was coming from. I didn't want to have beef with people. Those guys I did have beef with were guys I liked. I liked their work. So, the way I saw it, it was counter-productive—against everything I believed in and felt about the culture. That was kinda the whole downside of the culture. It was deflating. I think that it becomes this oxymoron: "Dude, I really want it to be cool," but at the same time, "Don't fucking chump me. Don't try to fucking punk me. Because then we are going to have beef."

Most writers didn't go looking for beef, but they weren't going to let themselves be pushed aside either—nah, that was never going to happen. And that's really where a lot of that stuff came from. At the end of the day, it's street shit. That's what it boils down to. You start to realize the diversity of these relationships and these personalities and you're like, "Your work is cool, but you're a dick!" No matter how dope you are, it's just not cool to be rude or try to mess with people. After a while, I'd had enough. I was like, "I'm not with that game. You guys are not going to run that game in my department. I'll shut you down."

The pieces and the tags became super alter egos. They became the presence or the ghost that I left behind. That was power. It was intimidating. It allowed me to project my aggression and my presence. And that was important. It didn't matter that my pieces got crossed out. If you cross out one, I'll put up fifty. If you cross out fifty, I'll put up two hundred. It was really about the energy. The letters would get bolder and wilder, and the colors could be super aggressive. I went for everybody. When I painted whole cars, I covered everybody. I don't know who I covered, but that was

to be expected. There's just no way to be nice about that. There's a certain level of respect I have for the culture and the skills of other people. I'm not going to go over a phat piece. But I'm not going to think twice about going over some bullshit, some corny little whatever.

I didn't look at the scene like "Oh, you're a white kid" or "Oh, you're a black kid." It was more about personalities. The person. "Oh, you write Team Go Club? I don't care if you're white. If I like your stuff and your shit is dope, cool." It was never about not writing with white kids or not writing with black kids. It was more like who they were in the game, the skill they had. Or the traction they had. Or the way they did their thing. That's what caught my eye. If I met them and they were chill, even better. Why not? Made it more interesting. I wasn't a derelict kid looking to get into trouble all the time, or a 'hood rat constantly scheming on people. I had a bigger and broader interest in people that allowed me to attract a lot of different types of folk. I was trying to live my life, and experience and learn as much as possible.

We never imagined the culture would blow up the way that it has. Never in a million years. I'm super ecstatic and very proud of where things are today. The level of interest and interaction around the world is astonishing. I get emails from around the globe—Pakistan, South Africa, Australia—from people who love the work they've seen in *Style Wars* or *Subway Art*. It took me a long time to see the practical applications of graf because, when it was becoming something in the gallery scene, it still didn't have a natural flow that said to me, "Okay, this could be applied this way; this is something that an artist can create and get paid for." But now, it's become a lot bigger.

I remember my aunt once asking me, "Well, what do you want to do with your life?" It was 1980, and I was at the height of super smash... And my clear answer to her was, "I just want to paint. I want to be creative." I didn't look beyond that, in terms of how that was going to support me. And it took a while. Writers were doing massive collections of works for peanuts and got jerked big time in the end. I did plenty of group shows

and stuff like that, too, but it was bogus; it seemed there wasn't a true interest in cultivating the art. I knew there had to be a better way. When I got into gaming—as an art director—that's when I thought, "Okay, I really could rock this way."

I think the lack of interest in the cultivation of graf is the aspect I found most deflating. It was more like, "They're hot artists, you look pretty this way or that way." You were sorta held up as an attraction, and that bothered me. It wasn't genuine. I said, "Screw that! I don't want to be a part of that. That's not what it was about. We are real people, real creative people." Being a creative person is what got me into Parsons. I didn't have a formal art portfolio. When they asked me for a portfolio, I showed them a bunch of trains I had done. And they were like, "Yeah, we don't do that art here." At first, they dismissed the art and didn't want to let me in. I had to convince them that I was a good student. I was like, "I'll do this program where if I get one F or one B, you can drop me from the whole program." And they were like, "Fine, do it." I guess they just thought that I'd fail.

I painted trains until my third year in college, so 1987. I became super focused because I was already starting to gravitate towards a new world and looking to the future. I knew that I wasn't following the same path as every other guy—trying to be a gallery artist and all that stuff. I didn't want to do that. I chimed in every once in a while for a group show or something, but that wasn't the path I wanted to follow. I knew that I was going to go to school and paint till I couldn't do it anymore. And I did. Up to my third year, I was still doing full cars.

The last car I did: it might have been with Min on the RRs, but I think it was with Duro and my brother Mare. We did three whole cars. I think I really felt the effects of my education at that point because I started to make the clear connection with being an art director. I was like, "Okay, I'm an art director now. And I'm designing these three cars. These are my outlines. I want to use these color formations this way." I literally mapped out every component of each car and gave Duro all the colors

he needed to paint. I did the same thing with my brother, and then I did
a whole car myself. That's when I thought, "Wow, graf has changed." That
moment felt like the true end of graf for me. I couldn't do it anymore.
It wasn't the same. I realized I was becoming more of a commercial artist.
Also, by that point, some of my guys had died. Relationships had disap-
peared. It was really thin at that point. There weren't many of my partners
around anymore. That helped to seal the deal. Transit was already gaining
the upper hand on graf. And I was not going to continue to fight.

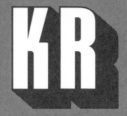

KR hails from Astoria, Queens, a neighborhood that wasn't widely recognized as a graffiti hotbed. But early into his writing career, he would discover that one of the most respected and influential style masters—Don 1—lived but a few blocks away. In a world where all of his local contemporaries largely had two-letter tags (and focused on painting two-letter throw-ups), KR, artistically, had greater talent—talent that catapulted him from trains to commissioned murals throughout Queens and beyond, illuminating the commercial potential of the form at a time when there were only a handful of writers doing so.

started writing in 1977, but it was a little earlier that I first began noticing graffiti. I remember going to see the Yankees at Shea Stadium; they played their home games there in 1974 because they were doing work on the Yankee Stadium. So I'd be on the train, going to the game with my brother, seeing bubble letters and characters, and wondering what it was. And there was some graffiti in my neighborhood—you know, Dean lived in Queensbridge housing projects, Don I lived in Long Island City/Astoria—so I used to see that stuff when I was a kid. I used to ask my mom, "What is that?" And she was like, "Oh, it's a bunch of punks." She had no idea I was gonna become one of those punks. Graffiti was a natural progression for me because I used to draw a lot as a kid. I was a big fan of cartoons, too. Graffiti became the art of choice, as opposed to doing landscapes or still lifes—bananas and fruit, and stuff like that.

There was this guy from my neighborhood who wrote Mace who showed me the ropes. He was down with Dean 3YB, who was originally from uptown. One day, I remember Mace poring over some photos of subway graffiti. I asked him why he was taking pictures of trains. He replied, "Look on the train. That says MC—which is short for Mace. That's my tag." I was like, "What's a tag?" I didn't know the language at that point.

The first tag I did wasn't even a tag—it was just a shape. It kinda looked like "96" in bubble letters, although it wasn't supposed to say anything, and I remember at the time thinking it was like a throw-up or something. To me, it looked like the shapes that I was seeing on the trains. I was II years old, in fifth grade or something, and Kiss was my favorite band. Mace is a little older than me, so the guys he knew were a bit more sophisticated. He introduced me to guys like Rob 78 and KB TSS. I went from doing a shape to getting into crews. My tag was Krome at the time.

I was really inspired by Don I's pieces. He wrote from '73 to '77, but his pieces seemed to run forever. I remember specifically two whole cars he painted in the late 1970s—window-down whole cars that lasted through to 1982, untouched. When I first saw his work, I was like, "Wow! This guy

can't be from around here." I thought he must be Dean's friend from the Bronx, because all the best writers in the world are from the Bronx. Don was replacing letters with characters. I know there were other guys doing that same thing on other lines. But Don was using Cascade Green with a dark green outline with a white 3D for support; his color combinations and the character he drew came from places I had never seen before, especially on the RR line. When I found out who he really was—and that he was from the same neighborhood as me—that blew me away.

I remember taking the RR to Queensboro Plaza and the 7 train to Shea, and seeing all the stuff from guys like Slick, Cliff 159, Son, and Pro. These guys did massive pieces. They were basically throw-ups with colors, but they were really, really neat and well filled in, and they stuck out in my mind. I remember they had this window-down whole car that said *Sonsational and Professional*. I haven't ever seen a photo of it, but it made such an impact on me. That was at the Queensboro Plaza station. The train pulled up and I was like, "Holy shit, look at this. Who the fuck are *these* guys?" I was forever piece-watching—taking the RR to Queensboro Plaza for the 7s, the RR to 59th Street and Lexington Avenue for the 4, 5, and 6 lines, then going to 42nd Street for the 1s, 2s, and 3s.

I really didn't have to go anywhere to piece-watch the BMTs because the trains on the RR would switch with all the BMT lines—the M, the L, the J. I could witness all of the action right there in Astoria. I did go to the Bronx to piece-watch, and I also went to Brooklyn, but I didn't have to go any further than 42nd Street and Times Square to see every line from every borough.

When I went to see bands, my friends would be like, "Hey, you don't look like you're getting into it." I used to just stand there and watch because I'm a musician. They didn't understand the way I was getting into it. I was watching every move and every subtlety. It was the same thing with graf. I really absorbed everything from the mid-1970s up, through to like '80 or '81. I wrote on the trains through to '83, but the whole style from '76 to '80 is what I really sunk my teeth into. That's why currently, when I do letters and whatnot, the style of my lettering has a soft flow to it as

opposed to the more hard-edged, elongated, skinnier letters that came out later, like the FBA style.

I think Dondi was really the one who stepped up with the best of both worlds: his letters were soft and hard. But to this day, I strive to maintain the funk of the mid-1970s in my pieces. What I do now is a little bit more technical than what they were doing then, but the essence of it is the mid-1970s soft funk that I love. They say you emulate your heroes since you can't be them. You become you. Yes, I was copying stuff, but I was bringing my own flair to it. "Biting" is complete plagiarism, but biting and then turning it into your own style, that's influence. I always say that I was an artist before I wrote graffiti, but I chose graffiti as my art and became a graffiti artist. We'd usually just call it writing. We didn't call it graffiti. Nobody was like, "Yo, do you write graffiti?" It was more like, "Hey, what do you write?"

I remember traveling on a train and being like: "I just went writing. The lay-up got raided. We had Cascade Greens and Flo-Master ink. We did insides…" Nobody knew what the fuck we were talking about, which was the point. Graffiti had its own language. That was part of the appeal. It was secretive—an underground society made up of cats from all over the city. At that time, there were only a couple of thousand people writing, but that all changed when *Subway Art* came out. Now there might even be millions of people writing graffiti.

And the amount of talent you see now in pieces—it's fucking ridiculous, bro. The illustrative backgrounds that these guys are doing and the metamorphosis of the lettering… It's gone from Cornbread and Taki 183 through to Stay High and Phase 2, to what dudes are doing in Germany: 3D stuff where they paint a wall and add a piece of plastic on the floor that is the same color as the piece. It's become this whole other thing.

And that's the whole other thing about graf. It's got its own evolution. You go from the single-hit tag to the bubble letter to the burner to the wild style to the incomprehensible to the fucking full-fledged fine art that it has become. If you take a wild style piece—like a burner—it doesn't look like anything else in art history.

My first time bombing was the scariest experience I have ever had: just the energy that goes through your body and the feeling of elation after you've done the piece, leaving the yard knowing you got over, and then seeing your piece go by in your neighborhood. I can't even describe it. It's like a movie flying by on a train with your name on it. I remember being in my homeroom class, on the fourth floor, at Long Island City High School. That room faced Queensboro Plaza. I saw the window-down whole car— *KR Sophia*—that I had done that weekend and nobody understood what it meant because there were no writers in my class. As the piece went by, I was like, "Hooooly shit, there goes my fuckin' piece!" I painted the whole damn piece—52 or 53 feet of train, or whatever it is. I was 14 years old when I did it. It was just an amazing feeling of accomplishment.

You definitely felt sneaky about it, too. It was a big secret. Certain people knew that I wrote, but even within my family it was a secret. I come from a very big family and my father was like a military cat; there was no way he'd have let me sneak out at 2 in the morning. Everything I did was in broad daylight at the M yard in Ridgewood. On Sunday afternoons, I'd spend the whole day in the yard and come home covered in dirt. I remember one of my older brothers saying, "Where were you, man?" And I'm going, "I helped my friend work in his basement." He's like, "Yo, where's your friend's basement, in a fuckin' coalmine?"

When it comes to the process of creating the piece, I always use musical analogies. The outline of the piece is the arrangement of the song. The finished piece is the whole song. And the actual execution of the piece is the live version of the song. It feels ethereal because when you see a band perform live, the music happens in front of you, but where does it go? It dissipates into the ether. It's the same thing with graf: that piece you did lasted a certain amount of time and then it was gone. That's why, if I had any kind of vision when I was a kid, I would have taken a photo of every fucking thing I saw. I would have taken photos of tags, throw-ups—just everything. I would have taken cameras with me everywhere I went. But I never took a camera because I always thought that if I got caught, that would be evidence.

Me, Sick Nick, and Foam wrote a lot together. We would meet up
with Bil Rock RTW and go to the tunnels in the city. I went up with Mace
a couple of times, and KB—we'd do insides. We'd go out to Sheepshead
Bay, too.

Something I always found interesting was the particular "K" that KB
wrote. He got it from Dean, who also used to write KO, which stood for
Knock Out. That "K"—everybody thinks that Dean created it, but he got it
from IN, aka Kill 3. Kill 3 started doing that "K," then Dean took it, but
KB—which was short for Krazy Boy—perfected it. I used to write Krome,
but I changed it out of respect to Krome 100. I dropped the "M" for an
"N," and became KR One. Tags with a "K" were popular in Astoria. We
had Krazy Boy (KB), Krazy Zap (KZ), Krazy Nick (KN), Krazy Writer
(KW), and KR. There was even another KR before me, Krazy Rudolpho.

There were a few places we all used to meet. One was Broadway, right
by the Strand Theater. There was a place called Sip N Smoke, but we used
to call it Sip N Choke. We had tags on the inside of the fucking movie
theater. I remember SN taking out a can of flat black and putting a tag
there while the movie was playing. We used to meet the TSS crew, aka The
Super Squad, by Hoyt Avenue, right under the train station at Astoria
Park. KB would be there, as well as other dudes who didn't really get up
on trains but killed the streets. I can't forget Johnny B and Chisy. People
always thought they were boyfriend and girlfriend, but they weren't: they
were just two dudes who killed shit. Johnny B actually wrote on the IRTs
for a short time. He also used to write Gen. He was a great artist. He did
a dope *Star Wars* at the handball court underneath the Triborough Bridge.
To me, it was as good as a Lee handball court.

One of the last trains I did was with Erni's crew, New Wave Artists, in
the winter of '82. Erni was there, along with Foam, Size, and Midge. We
made our way up to Esplanade in a station wagon that belonged to Foam's
father. It was one of the few times that I ever drove to a lay-up. During the
winter of '83, I went to the lay-ups in Astoria and wrote on a train for the
last time. The scene had started to become a lot more violent. I remember

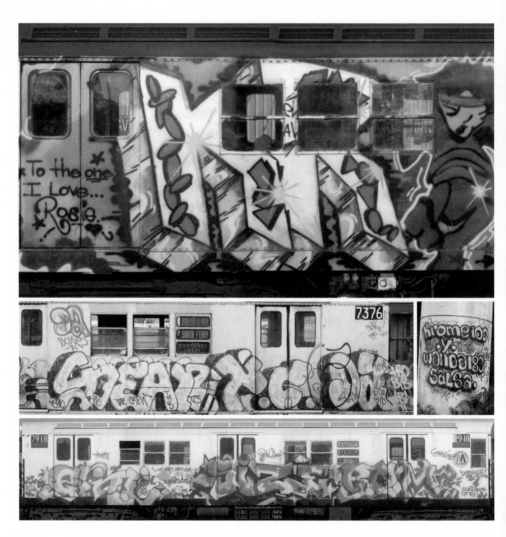

ABOVE KR, 2 Seventh Avenue Express, 1983. **CENTER LEFT** Dean, 1 Broadway Local, 1981.
CENTER RIGHT Krome 100, under the George Washington Bridge approach, Manhattan, 1977.
BELOW Erni, Size, Rom One, 2 Seventh Avenue Express, 1983.

asking friends of mine if they were going writing. One time, this kid said, "Yeah, check this out." He had a fucking meat cleaver. This other kid had a bat with nails in it. I was like, "What's that all about?" They were like, "Just in case." I replied: "Just in case of what? What are you gonna do, fuckin' hit somebody over the head with a bat with nails in it? That's fuckin' retarded." They just thought I was a punk. Yeah, whatever, I'm a punk. That was it for me.

I started getting more heavily into music. You know, "I'm gonna go to the studio and listen to fuckin' Judas Priest." I grew my hair really, really long. I always wrote graffiti, but I just stopped doing it illegally. Actually, I was doing murals in Astoria before Lady Pink came into town and did them. In the mid-1980s, I had a bunch of murals going. I was getting paid for it, too. I remember standing on 38th Street and Broadway with like fifty people around me. I looked like the drummer from Anthrax. And some old lady came by me and she's like, "Ya know, you're really making the neighborhood look like Harlem." I just started laughing. Me and my friends were blasting Manowar while I was doing a gigantic mural and getting paid for it! Martin's Paint was right across the street. I was buying paint and stealing more of it, even though I had enough money to pay for all the paint I needed. I just couldn't help it.

It was amazing, man. I'm so glad that I took part in it when I did, and that I'm still doing it now. I still feel that I'm nurturing the inner child by continuing to do something that I did when I was a kid and liking it so much, as opposed to dudes who get together once a month and drink beers and play softball. I'd rather do a piece with Dean BYB—RIP—than play softball any fucking day.

LADY PINK

In the 1970s, there were more than a few young ladies writing their names on the walls right alongside the boys, most notably Barbara 62 and Eva 62. In the 1980s, Lady Pink would rise to become the most iconic female graffiti artist the culture has known. Pink, however, has always been more interested in being an artist and writer first—just like the boys—stretching beyond the "female" box that men have spent so much time constructing. Important institutions collect her work, which often explores surreal, otherworldly themes.

The first time I ever went to a lay-up, I was with my friend Erni from high school. We'd lied to each other about having been before. When we finally got inside the tunnel and found ourselves in an empty subway car, we were so scared—and thrilled—we ended up confessing that this was our first time. We were 15 and overstayed our welcome: it was daylight by the time we left. We hadn't realized the sun had come up and a new day had begun. When we eventually returned to Erni's grandmother's house in the Bronx, his folks knew exactly where we had been because we were still dirty and covered in paint. They piled us into the car, drove me home to Queens, dragged us into the living room, and let us have it.

I lived in a private house in Queens, on the ground floor, so I could escape. I would climb out of my bedroom window, jump 10 feet to the ground with a bag of paint, and go meet my friends in the middle of the night…then try to sneak back in before my mother woke up. She knew that I would sneak out sometimes, and when I tried to creep back in, she would be waiting for me in the dark and dish me a nice smack in the head. I was completely uncontrollable as a teenager.

I had already been writing graf in junior high school—around the building and around the block. But when I went to the High School of Art & Design, I met some boys who were doing subway trains and it seemed terribly exciting. That was the thing to do. Everyone seemed to be striving to get to the subway tunnel and yard and actually put it up on a train—with that came admiration. I assumed I could do it too, I think, because the feminist movement was catching up with me. Us girls were busy proving we could do anything the guys could do and there was no stopping us. The more we were told we couldn't do something, the more we wanted to do it.

I was very gung-ho about getting to the subway trains and doing that. We were the most popular crowd in high school, the most popular table, and we wanted to keep it that way. You have to keep going out there and doing your thing bigger and better every year in order to stay on top. Once you meet the guys who've done the big trains—people like Lee, Zephyr, Crash, Daze, Futura, and Dondi—you realize what the best of the best can

do. You want to do that too and run in those circles and be accepted and respected and looked up to, just like those guys. They were heroes and royalty of the underground, and who didn't want that?

I met a whole bunch of those guys in one shot at Fashion Moda. I knew Mare 139 from high school; he was in the year below me. Through him, I was invited to be in the very first show at Fashion Moda. I had actually met Lee earlier that same year, in September 1980, at an exhibition of Henry Chalfant's photographs—one of his first with the pictures that would wind up in *Subway Art*—at OK Harris in SoHo. There, Mare introduced me to his brother, Kel. Lee showed up and was completely surrounded, like he was a rock star. Everyone pushed me to meet him. I was the only girl and it seemed important, for some reason, that we met. We met again at the very first Fashion Moda show. That was when I realized how much more talented the older guys were in comparison to my high-school friends. The older crowd had opportunities—painting, exhibitions—that were out of the reach of my high-school friends, so I abandoned them and moved on to the more experienced writers.

I got my name from my boy Seen TC5. He thought I should have a feminine name if I was rolling with them. Nothing's more feminine than "Pink," and the letters appealed to me: the "K" kicks out real nice; the "I" is really cute and you can dot it with a heart; and the "P" begins very slight and you can do things before it. It was all about style. I was a bit of a bookworm and devoured historical romances. I read that trash as a kid. I was always in love with the aristocracy of Europe—the dukes, Lady This and Lady That. I titled myself like royalty and our table ruled over everyone in high school, but I never actually tagged the word "Lady"—it's just my full name. I don't want to be confused with other Pink Ladies that have appeared over the years. There was a Pink Lady in the club scene back then who sold pink cocaine, and you have no idea how many people used to ask me to supply them with some.

My very first piece, I think, was in the 1 yard with Seen. That was the first time I had painted outside and I realized how incredibly tall the

trains were. I was too short for the job. My piece was like 2 feet tall; it was so small and pathetic. The first time I did a large piece with everyone else, I was in the Ghost Yard. I was harassing those guys to take me to the yard and they wouldn't. When they finally agreed, they told me to meet them inside the yard. I climbed a big fence, got inside the yard, and waited. Then I saw them coming up the street, peeling back the fence, and just walking right in… I hadn't even noticed that the fence wasn't attached: I was too busy climbing, and the guys in the tower—who turned out to be Seen TC5 and Kase 2—were too busy laughing at me. That was the first time I'd met Kase 2, and he did my outline. Seen might have helped out as well. This was probably in '81 or '82.

While we were in there painting, a group of guys came in with chains and sticks. They were looking to rob toys, and were making noise and attracting attention while we were busy doing a train. When Kase saw them, he turned and yelled, "Get the fuck out." Those guys, realizing who they were dealing with, just said "Yes, Kase" and "I'm sorry, Kase" and quietly retreated. That was my first taste of the kind of power that comes with fame, the kind of respect you can earn if you're good at what you do. The underground ruffians: I would never have got them to leave—they'd have robbed us. I'm glad we had Kase. We were under his name and he was looking out for us that way.

It was more usual for me to go in the daytime. The D yard was a nice daytime spot, and some of the tunnels on the A line. We couldn't all escape from our homes at night, so it was better to cut school or not go to school at all and head to the yards. I mostly hung out with the TC5 guys from high school, seeing them as my teachers. Once in a while, I went out with the older guys like Crash and Daze. I've gone painting with a lot of different people, including Skeme and Agent.

The whole experience was an exercise—part military maneuver, part ninja. You're sneaking around on your hands and knees, hiding in a bush for two hours or in some dark alley with a bunch of people your age, and trying not to feel silly because it isn't a game: people actually get arrested

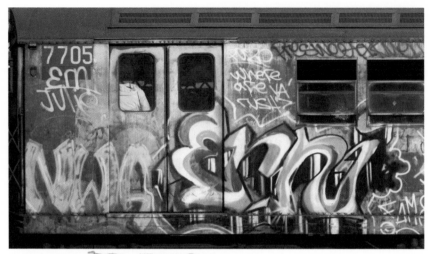

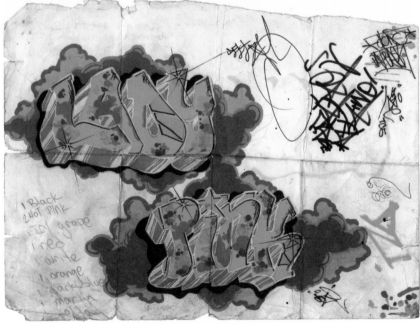

and killed doing this stuff. When you get in, you can't see a thing and you don't know what's going on. If you're just starting out, you're usually in a state of panic the whole time and people are talking to you, telling you how you escape and get out, but you don't hear them because you're so worked up.

You're just terrified and hoping you can see in the dark and do a straight line and not get arrested. Your heart is in your throat and any loud noise will make you jump out of your sneakers and pee on yourself. But amongst all of that, you have to create a piece of artwork. It's a lot easier to be a bomber and move around quickly: you make your mark, it takes a couple of seconds, and you move on. You're always on the move and in motion, so you're looking around all the time, while being aware of where everyone is and what's going on in the car. If you're standing in one spot trying to do an artistic piece, you're a bit more vulnerable: anybody can sneak up around you or behind you and grab you by your feet. You always have to be looking over your shoulder and hope that nothing happens to you, which is a vastly different feeling than the relaxed atmosphere you have in painting a mural or a piece of artwork in your studio.

Once all that drama is over and you're in there doing this piece of art, you just hope for the best. You're working in the pitch-black and you can't see the colors or what you're doing. You have to be really good at it, so that your piece can come off in the daytime. You're doing most of it half-stoned. So you're under the influence of some drug or liquor, it's dark, your friends are pressuring you, and people who are better are looking at your art and critiquing it. It's not the nice critique that the movies get. Kids can be very cruel. They laugh at you, point, and call you all kinds of names. They're particularly cruel if you fail, so the pressure to do something worthwhile is immense. A lot of people with limited skill can't really

ABOVE Erni, 1982. **BELOW** Lady Pink, outline by Doze, *ca.* 1981.

do "art." They can only do the bombing, and that's fine. At least you can do quantity—doing a whole lot everywhere. When you destroy and kill everything, you can get an equal amount of respect. Also, it's a difficult amount of manual, physical labor, which is why a lot of women don't take to it. It also takes a bit of a criminal streak—a personality trait that seems less common in women.

There were a lot of women writing before me in the 1970s, but by '79—when I started—they were done. I did meet other women in the early 1980s. There was Lady Heart and SS—this little white girl from Brooklyn who was just a bomber. She got *up*. I did some nice train painting with Lady Heart. I did meet some girls over the years, but they never stuck around for very long or did a whole lot of work. In the early 1990s, they started to appear more and more, though.

Being a female in the 1980s was pretty awesome. I did have other girls that I brought along with me who weren't writers. My sister dated some of the guys, and everyone kind of dug that. After a while, she ended up being dragged to train yards and subway tunnels. Her experience was different from most girls. She was just a regular in the train yard; whole trains were rolling by and the fear that goes along with that is exhilarating. Being the only female amongst all those guys was pretty interesting. I have to say that if it hadn't been for my sense of humor, I wouldn't have got as far as I did. Most of the older guys started looking out for me as a little sister and felt protective. As we traveled the world with our shows, I always looked up to them for advice and guidance. I was dating Lee for a while, so I gained respect from some writers for being "Lee's girlfriend." I got a lot of respect for that, but I had to hold my own. I wasn't just a decorative little girl like the others. There were dozens of them coming out of my high school. You'd see them in black books and stuff like that, but they didn't have the nerve to go into a train yard and do it at night, or even learn to use spray paint for that matter. They just liked to hang around all those very cute boys, and there were a lot of them hanging around.

Police would grab these interracial groups of teenagers and search them for graffiti materials because these groups didn't really exist outside of the graffiti community. It was weird. We had white kids, black kids, Asian kids, and Latino kids all hanging out together and not missing a beat. Most crowds and groups tended to be segregated, and even in school we stuck to our race. The graf kids were a pretty mixed bag, and the police were aware of that. Even the economic backgrounds were mixed: we had white kids who were well off and black kids from the ghetto who didn't have two nickels to rub together, and they would get along and paint together as friends. It's the thrill, the excitement, and the adventure that appealed to us; that's what graffiti brings. Even the kids who had money and came from a good family couldn't go buy their spray paint because a big part of our culture was lifting it.

I was awesome at stealing paint. Lee taught me how to do it correctly. You're not supposed to carry a big bag and fill it. You have to put the paint on your body and, as slight as I am, I could go into a shop and walk out with fourteen cans. They wouldn't suspect me, and ideally we would use the teenage boys as decoys. I would go in with my teenage friends. They would go over and start eyeballing the power tools and everything else that was expensive, immediately attracting the attention of the store clerk. I would be over in the spray-paint aisle, filling up my winter coat or my portfolio.

I've been there when people were arrested. Iz the Wiz was caught stealing paint but I got out the door just in time. A lot of times, I would talk my way out of it. I talked my way out of handcuffs twice, and out of a cop car once. I've talked my way out of all kinds of situations. I would say whatever came into my head. I talked my way out of a police station when I was just 16. I was grabbed, along with Lady Heart. We were in high school with baseball bats trying to beat up a toy and they took us away. Lady Heart was 15. She was a minor. That's when I first met her mother, who never liked me after that. The police did call my mother and told her I'd been arrested, but at the end of the day I talked my way out of the precinct.

They couldn't believe such a polite, small, intelligent thing was in high school with a baseball bat. I had the gift of the gab back then.

By the mid-1980s, most of the stuff on the trains was being destroyed by Cap or other copycats, or we had mostly grown up and it was time to start earning a living. I was taking the gallery thing a little more seriously. Most of my friends had moved on and the crowd I hung out with wasn't painting trains anymore. It seemed like a teenage thing to do. The laws were changing as well and became a little harsher. It wasn't a misdemeanor anymore. It was just time to stop. There weren't any nice cars being done. It was all about beef, and stuff was being destroyed. What was the point in spending all night doing something big and beautiful if it was going to end up getting dissed?

I was schooled early on by Lee and the other guys to take that gallery thing seriously. I was 15 and hanging around Keith Haring, Basquiat, and even Andy Warhol, but I honestly didn't realize the importance of it all, except for what the older guys were telling me. I had faith in their words of wisdom, so I followed their instructions. I worked on quality work using quality materials, while following up on all the business deals that came my way. I wasn't a fly-by-night kind of artist. I did it for real—like a job. We were hanging with the East Village crowd, so that taught us to take the art career thing seriously.

I've been a fine artist since high school. People choose to call me a graf artist, but honestly that was just art education for me. Some people go to college, but we did graf; that's how we learned to move on in this world. My work has increased in value considerably over the years, but I also enjoy doing public murals. My husband and I, for many years, were running a commercial mural company and that's how we've managed to survive. We are very versatile and able to handle all styles of artwork, from contemporary to classical to cheesy stuff—whatever people want on their wall. We are very accomplished at what we do and most of the people who work for us tend to be graf writers. The speed at which they work is vital, I think, for the jobs that we take on. Graffiti was merely an education,

when we were at college, that prepared us for all kinds of situations. We've branched out into all sorts of fields in the arts—film, photography, you name it.

Most of us artists paint and create and work not because there's a market out there, and not because people like it or want to exhibit it. We paint because we have to. We view the art market from afar—like it's here one minute, and gone the next—and every time it grows big, there's always a different label that makes it exciting again. This time we are being called "street artists." I don't really feel like a street artist, but we don't have any control as to what folks want to label us. People still call me a graffiti artist and I haven't done graf in decades; I don't practice my lettering very much and I don't do pieces. Once in a while, I would cough up a graf piece on a legal wall, but not that much.

I did go back to graf in the mid-1990s when I first met my husband and we were doing freight trains for a while. It was fun and exciting. Very low security. It was different from being in a gallery. In the middle of the night, I could paint all the crap I wanted and I didn't have to sign it. I could do all kinds of crooked goofy stuff, silly cartoons, funny stuff, and I didn't have to be sophisticated or hardcore. That was fun, but I ended up getting too much work during the week, and the last thing I wanted to do was paint in the middle of the night on the weekends in the freezing cold. It became less and less exciting, with me doing hard manual labor that I wasn't paid for. There are some people who still enjoy it and continue painting and thrive on the excitement and adrenaline rush like a fireman or a policeman—people who love the kind of rush you couldn't get sitting behind a desk. I've outgrown that; I don't need that excitement in my life. With that excitement comes the danger of getting hurt or arrested, and having to go to court for months and months, and paying expensive lawyers, and even going to jail. None of that stuff appeals to me right now.

On the night John Lennon was shot—December 8, 1980, I think—Iz the Wiz called me up. He was someone I'd just met and I didn't know him

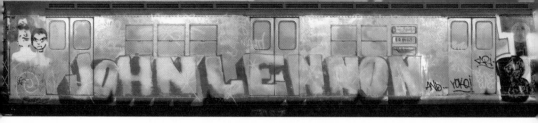

John Lennon/The Beatles by Iz the Wiz, Lady Pink, and Mare 139, 1980.

too well. He told me, "John Lennon just died." He had just woken me up—I was kind of fuzzy—and my first question was, "Who's John Lennon?" I was 15 and didn't really listen to "white people's music." I was into disco, not rock and roll. I knew of the Beatles—everyone did—but I didn't know them by their individual names, and when I asked who John Lennon was, Iz was shocked. So he said, "Let's go paint a train in his memory," and I told him, "OK, great."

A week after he died, we painted the *John Lennon* train. I took my friend Mare with me, and I'm not sure Iz was thrilled about that. I think he was looking for a little alone time with me in the dark... Mare proved to be invaluable; he really helped out and filled in a lot of the space. I climbed around all night long like a monkey in the dark. It's crazy: you're knee-deep in garbage, and there are things ruffling in the mess. There were very large roaches and rats, but you can't show you're scared or scream. You just have to push through and paint like a big macho dude and get it done. We were done by morning. When we came out, it was broad daylight and we got breakfast at a restaurant. I knew I was going to be in trouble when I got home.

I do remember seeing it run. I remember seeing it four years later as it pulled up in the train station. We did it on the 2s and 5s, and it ran for four years. I believe it was a record for a piece to run that long. Maybe it was because it was a straight letter piece that everyone could read. I don't know if Yoko Ono ever saw the piece, but I painted the John and Yoko characters on the train. I barely knew what she looked like. Since then, I've grown to love the Beatles and their music. Don't get me wrong: I do like white people's music. It's just that, back then, I was only exposed to

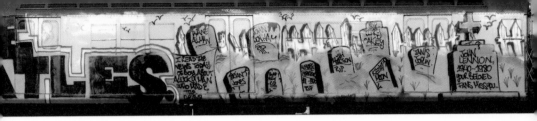

funk and disco; my hero was Donna Summer and I was a disco dancer. All of my friends were African-American or Puerto Rican and didn't even know white people. Graffiti obviously changed that for me.

We have become the biggest art movement that the world has ever seen—bigger than the Renaissance, bigger than any other art movement. Ever. I'm proud of my involvement; proud of where the culture has gone. Way back when, when I first started writing, no one could have predicted where we are today. People are climbing fences and entering train yards all over the world.

SAK

Before Sak wrote Sak, he wrote Hypo—which was inspired by the writer Hyper, aka Mackie. Some of his friends who had been involved with writing a bit longer told him that it would be wise for him to get a new name, and the name that stuck was lifted from a brand of garbage bags. Sak's tale reveals the level of focus a master writer has to maintain in order to survive. There was a war going on with the Metropolitan Transportation Authority, and Sak was that general who continued to rally as soldiers fell victim to strict parents, bloodthirsty bombers and the stiff penalties that an 18-year-old fame monger could face.

I came up in Manhattan and witnessed the pioneering years of graf. I lived in Inwood, in the north of the island, and would see a lot of cars—cars that were elaborate and full of expression—on the Broadway Line, which ran through my neighborhood.

Back in the 1970s, New York had a lot of street gangs. If you remember the movie *The Warriors*, there were a lot of gangs like that. A lot of different turfs and 'hoods. The city was the exact opposite of how it is today. There was a lot of crime and drugs being done. You could drink a 40oz on the street without being harassed by police. You could even murder somebody and get away with it.

My first graffiti adventure was in '79. I started out motion tagging. My very first yard was the Ghost Yard in Manhattan. The spooky name comes from a story that somebody got killed there and people would hear screams as the spirit roamed the yard. It's a big yard that houses multiple subway lines. All the IRT lines were there, with the exception of the 7 line. The 7 was like the trust fund baby of the IRTs and was segregated from the rest. I distinctly remember back in '76, '77, '78, they used to switch the IRT 7s with the Broadway and 4 lines. You'd get these Cascade Green and Antique White cars running. The 7 trains had a different color scheme from the other IRTs. Every now and then, they'd mix in a couple of the green cars with the other IRTs. The Ghost Yard had all this, plus the As, Ds, and CCs.

I vividly remember going to the Ghost Yard for the first time. I was with a neighborhood friend who wrote Frozen and we were like 13 years old. This was in 1980. We used the route most writers would frown upon—entering via the front entrance, where all the trains would leave. On that side there was a big watchtower, and we would have to run over a series of tracks—like the length of a football field—to get to the trains. The yard started at 207th and ended at 215th, and we would enter at the 207th side; it took us six minutes to get to the trains and out of sight. I started out in '79 with the name Busy Bee, but switched to Hypo. The first time I spray painted on a train, back in '80, I wrote Hypo. The piece

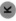
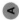

ended up halfway under the windows of the car... It was scary, man. You could hear loud noises and different things, but it was oddly quiet at the same time.

At that point, I was just going through names and trying to find the right one that fit. I was young and wasn't seasoned. There was a guy who wrote Hyper/Mackie; I'd seen a lot of his stuff back then, so I guess I just fashioned my name after his. When some peers of mine who were into graf said Mackie was going to get me, I got spooked and thought I'd better change my name. That was in '80 or '81. I went by the name Active until '83, when I finally settled on Sak. Active: I fashioned that name from Alive 5, who was doing elaborate whole cars on Broadway. I was heavily influenced by FBA because there was a period when they were the only ones doing the line; from '80 to '82, they were pretty much keeping it alive. In '83, I happened to see "Sak" on a garbage bag and thought, "Hmm, that's a nice name. I'm going to go with that."

My crew was MBT, which meant Masters Burning Together; my boy Frozen came up with that. Later on, it was the Master Blaster Team and Mo Better Team—and other meanings that I can't remember right now. Initially it was Frozen and I, and we had a couple of other neighborhood kids who eventually fell off with graf, but I was a diehard. Frozen had very strict parents, who hindered him from doing a lot of stuff. I had a stubbornness and drive that pushed me to do what I did, whatever the consequences.

Then I met my second partner, Rize. Rize and I pushed the crew and got it off the ground. As time went on, writers who were skilled enough to hold their own got down with us, including Swan 3, whom I had known since childhood, and my deceased friend Run. There were five or six core

ABOVE Active (Sak), Reka, 1 Broadway Local, 1983. **CENTER** Sak, 1 Broadway Local, 1983. **BELOW** Chaz, 1 Broadway Local, 1983.

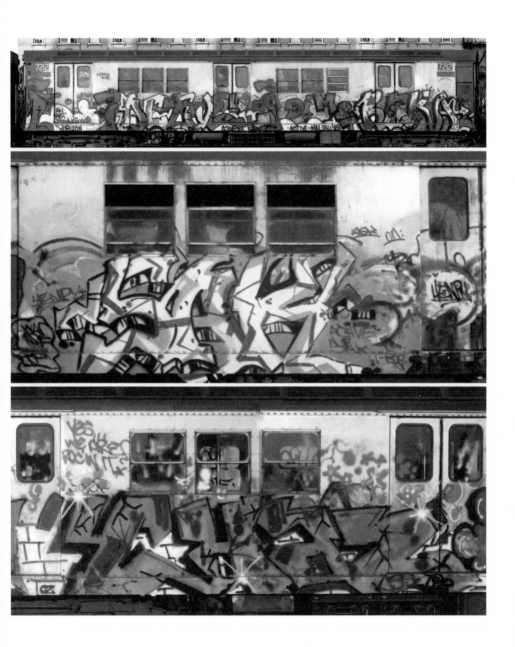

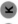

members. You just had to have skill and determination to be in the MBT crew. My prime reason for doing what I did was to carry the baton for Skeme because guys like that started to fade away.

People say Broadway was a style line, but I beg to differ. Broadway did have some nice pieces, but I remember it being mixed from the late 1970s to the early 1980s. If you saw a I train pull in, followed by a 2 train, out of 10 cars on the I train you'd have maybe one or two good pieces; the rest was bullshit. On the 2 train, on the other hand, there would be pieces with elaborate detail that blew my mind. Broadway was scattered. It wasn't consistent. I was trying to make Broadway a style line because, when the guys who were killing it before me died off, I had to keep order within my crew. We did an okay job at it. I'm not saying I was the best, but I was a relevant force in the game.

I did a top-to-bottom, end-to-end with block letters and characters. It was my understanding that some guys from FC were mumbling under their breath about me, but when we met in person we were civil. I guess you could say it was a friendly rivalry; we would see each other in the yard and everything was love. For the most part I tried to get along with everybody, and if I couldn't get along with someone, I figured they were an asshole. I never looked down on anybody. It didn't matter how wack you were: we probably could do something or I could teach you. I did have a problem with this one particular writer who was a big fat loser with no skills. He wrote Chaz and was a toy, a big time hater. He was jealous. At the time, when we bumped into each other in the yard, I was a lot smaller than him. He was pushing 300 pounds and I was 130 soaking wet. He did scare me: he was a big dude and a lot of times he gave me the feeling he wanted to cause me harm. There was a time I was afraid of him, but the next year my balls grew and the fear went away. For the most part, that was really the extent of my beef.

My family knew I was an artist and that I was into graf. My mother didn't say anything about it, nor did my father. It wasn't until I got busted in the yard that it came to a head. I had tried to do a piece because I hadn't known any better; it was a rookie move. I was about 14 at the time. There

were some kids at school who were into writing and wanted to come to the yard. After school, I went straight there to join them. It was the middle of the afternoon and I painted on the outside facing the watchtower—so I was a sitting duck. The guys I was with were 13 and 9 years old. Out of nowhere, these work bums came closing in on us. The 13-year-old and me started running, but the 9-year-old kid froze up on us and started crying. They took us to the watchtower and called our parents. We ended up in family court, and the fine back then was $113. Imagine if you did that today: you would probably do twenty years. That just shows you how the laws were back then.

A week later, I was back in the yards. We went to the 207th Street entrance. There were around six of us and we all got busted. They took us to the watchtower and called our parents. My mother came and cursed me out, but they only picked us up for trespassing; the detectives came and let us go. The fact that I got caught twice in the space of a week was crazy.

I had a long snorkel coat with a fluorescent orange lining. The snorkel had holes in the pocket, so I would go to the store and drop the cans in the holes in my pocket and line them up with the seams in my coat. I would then walk really slowly out the door. At the time, there was a Woolworth's on Dyckman Street. One summer, I got bold and went in with a brown paper bag opened up like there was something in it; I walked to the back of the store and filled up the bag with paint. The store manager confronted me when I was walking out, mushed me, and told me to get the fuck out of the store.

I went up to Yonkers to this store, CH Martin. I would go in there with my book bag and rack up lots of different colors. In another store, I had to buy a can of paint in order to rack. This was near Henry Chalfant's studio on Canal Street. There was a hardware store directly across from Pearl Paints, and me being a man of color, the microscope was on me. I went in there and innocently bought two cans after I'd stuffed seven in my bag, and I'd do this before they closed for the day. I'm keeping it 100 percent: I had to do what I had to do. I bought two and got eight free.

The most intense years, I would say, were from '83 to '86. It is a little known fact, but back in '83 I met Tack FBA, one of my heroes. He was killing Broadway. He also painted on the 5s and the 2s. He took me under his wing and gave me some outlines. I wasn't at the point where I could piece beside him, but he never turned his nose up at me. I was starstruck just to be in his presence. Tack had kind of slowed down by the middle of '83, and I wanted to get down with FBA, so I asked him if I could. Tack said, "With your next piece."

My next car...hmm. It was a Saturday afternoon, and I was determined to make it a success to get down with FBA. Everything was going well when, all of a sudden, twenty Ball Busters came into the yard and chased us out. We left the yard and waited about two to three hours before going back; I was determined to finish that car. Even though I became one of the leaders of FBA at one point, I wasn't fully recognized as a leader. When I came back to the yard, I found the car fucked up. My characters had been scribbled out, but I was like, "Fuck that! I'm finishing this car." I pulled it together and that was my first Sak piece. I wrote "Happy Easter. Still Active." That was me transitioning from Active to Sak, letting people know that I was still around but just under a new name. The Easter egg in the middle was generic, but the character with the Afro was typical of the FBA, and I finished it off with the MBT on the end. When Tack saw the car, I was officially put down. He was impressed.

There's a car we did with the IRA on it. On this car, you can see we started to get better. IRA was a crew Rize was down with. Rize had a lemon yellow fill-in with a baby-blue outline, and I had a hot pink and baby blue fill-in with a red outline. We did this train in the 1 tunnel. The 1 tunnel was DANGEROUS. I didn't have the backing of FBA or Tack, but just went by myself.

I met my partner Rize at the supermarket back in '81. We were delivering groceries and stuff like that. He had a stack of pictures and I saw he was into graf too, and we became friends. We ventured out to other lines.

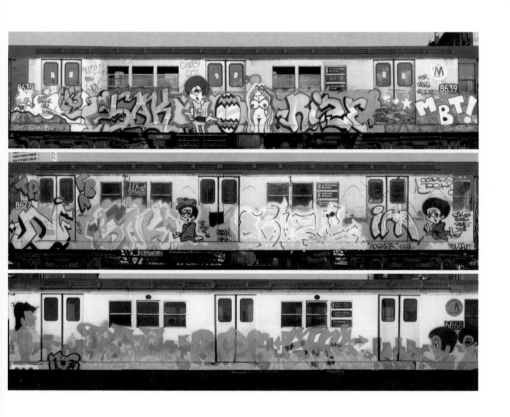

ABOVE Sak, Rize, 1 Broadway Local, 1983. **CENTER** Sak, Rize, painted in the 1 tunnel, 1983.
BELOW Rac 7, Rize, Sak, unfinished, 6 line, painted in the Ghost Yard, Manhattan, 1983.

We were on the 1 line, but it didn't have a whole lot to offer in '81. TDS were still doing it, but not as much. A lot of their stuff was getting buffed, and the line was kind of dead. I got tired of it and decided to go to the 5, and Rize and me took pictures. I went benching on the 2 and the 5 on my first time out. I caught a Phase 2/Butch 2 car with a wizard at the end, but the whole car was fucked up.

My main influences were FBA, TMT, and TDS. I was TMT at the time and I just didn't know it—not officially, but it showed in my work. I took stuff from them subconsciously—or consciously—along with more current FBA stuff because, by this time, TMT and TDS weren't really doing anything. FBA was holding the torch with TFA and TNT, so those were my influences—a combination of those guys and my own inspiration. I didn't literally take, but just used bits and pieces.

As for the Rac/Rize/Sak car that wasn't finished (p. 111), we were in the Ghost Yard and that car was done on the 6 line—it's the only car I ever did on the 6. I did the characters on both ends, and you'll notice that next to the character there's an FBA. Rac 7 at the time was geeked up, high on coke. There was an empty lane and train behind us. A train started coming towards us and I knew it was nothing, but Rac 7 was so paranoid because he was high. He started packing up and yelling, "Come on, they're coming!" I was trying to tell him the train was just parking for the night, but I couldn't convince him, so I just packed up with him. I wasn't going to stay there by myself. That car would have come out dope if we'd finished it. The last time I spoke to Rac 7 was three decades ago. Rize: he's busy working, but every now and then we touch base.

One of the last cars I ever did on Broadway was with my old partner Run, who committed suicide. We did a car with our names and a city skyline silhouette similar to the Skeme/Agent car that most people have probably seen before, the only difference being the characters on it. I think time was against us, so we just abandoned the car. I painted a couple of times on the 5s—like two or three times in '87—but it was a done deal after that.

The trains went away. I lost touch with the whole scene. During this period when the trains were phased out, we were lost. The ones who understood painting—like Reas and those guys—kept hope alive towards the end of the subway era, painting the last of what was running. We were still doing renegade illegal stuff at night, but we were lost. This was before the internet, so there was no networking. Back in the day, you met either in the yard or through someone. Between '87 and '95, I lost touch with a lot of people and wasn't doing much, but then I started back up.

Even though we were doing it for recognition, what we did wasn't in vain. What we did caught like wildfire, man—like coast to coast and in countries around the world. I met a guy in Africa who's a writer. The art is in Senegal, Spain, Germany... I like the direction it has moved in. But I look at everything from a different perspective now. I'm more about that traditional formula, which is what I do. I may have upgraded styles, but I still use the traditional formula. I believe that the art has come full circle. It's an art that can't be taught in college. It's something that comes from within.

SHARP

Sharp had a serious desire to paint trains and wasn't going to let anyone stop him doing just that. At a time when established graffiti crews ran the lines with a collective iron fist, Sharp, an uptown boy, pushed his way past all the politics and got up. His dedication to the art and the culture of hip hop at large would factor into a style that was steeped in ancient calligraphy, yet fortified with the grit that can only be born in the streets and back staircases of New York City. Sharp's visual vocabulary has taken him around the world, but the essence of the Big Apple lies at its heart.

The naked woman with the bosom (overleaf) is a piece from my heyday. Delta 2 and I painted it on a 4 train on elevated tracks—probably Woodlawn—around 1984. We were doing these theme cars back then. That one was supposed to be called *To all the girls we ever loved*. Painting trains on elevated train tracks was particularly difficult. When you think about the people who were kings of different trains, most of them did their pieces in the yard. Painting on the elevated opened a whole cornucopia of situations that didn't exist when you were in the yard—one of them being that you were 40 feet above the street on wood that was old and creaking. Sometimes you'd step on a loose piece of wood that would jump up and hit you in the face. It was scary. Plus, you were painting outside, so you could be spotted more easily. So we used to paint on that lay-up, but on the side that faced the park.

I remember one time we went there with Dez, aka DJ Kay Slay. He was amazed. It was the first time he'd been on the elevated—he was a regular at the 3 yard—and he couldn't believe his eyes. He was like, "Yo, how the fuck do you do this shit day in, day out?" He was really scared. I mean, when you're walking on that wood and you're looking down at the street below... Every time the train enters the station, the whole layout shifts a bit. Dez refused to hide under the train, so we did the pieces at the end, which meant he could walk around. Someone from the apartment building actually threw a bottle at him! All I could hear was him being like, "Ooh, ooh!" After that, I remember he definitely had more respect for us because we were always like the peons behind him and Skeme.

We painted lay-ups like that because, with the 4 yard and any other yard, there was a much greater risk of bumping into other people. There were just two of us. We weren't RTW. We weren't the Vamp Squad. We weren't CIA. We weren't a force to reckon with. Also, we were a lot younger than all the other guys painting at the time. That two-, three-, or four-year gap makes a big difference when you're a teenager. One thing we liked about the elevated lay-ups was that we could always just slide down the pole and get out of there. When you were in the yard, and say three

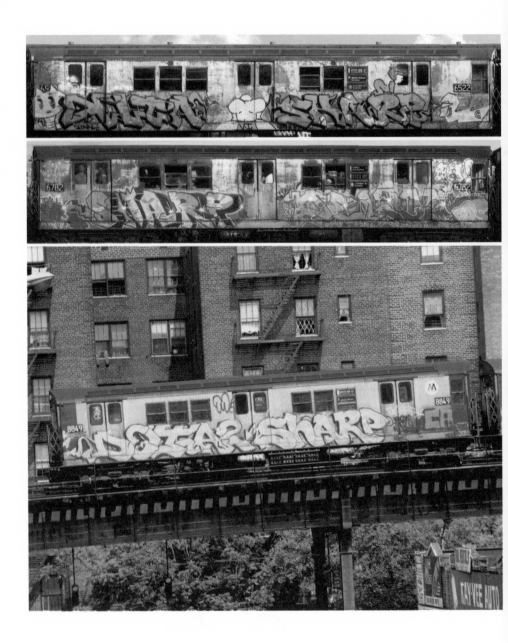

to five cars in, you were within easy access of the hole. If you were in the train or seven or eight cars down, or in the second set of trains, you were in the middle of the yard and could easily be surrounded. If you were caught, you'd definitely get your ass whooped. In the yard, you had other writers to deal with, work bums, and police. But the cops didn't want to walk on the elevated train tracks precisely because it was so scary. They would just go inside the train, walk the length of the lay-up, and open the doors on you. And then hope you got scared and just stood there. They weren't really ever going on the elevated tracks.

Once I got caught in the Kingston lay-up. I was with Delta and this other dude, who was a toy. He inadvertently saved us, actually. Someone had gotten robbed and, when we got out of the hatch, there were like fourteen squad cars waiting for us. We all took off in different directions, throwing things away. It wasn't until I was in the car, handcuffed, that someone said, "Yo, who robbed the old lady on the train?" I was like, "Nobody. We don't rob. We write." At the time there wasn't a lot of aware-ness, so he didn't even believe that there were trains down there. "Go down there and look," I said, but he still didn't really believe us because we didn't have anything on us. Then the other kid got picked up and had a marker on him. I was like, "Yo, you see! We write! We ain't stick-up kids." They were still hesitant when they transferred us to Central Booking.

Back then, there wasn't an active anti-graffiti squad like there is today. There were these four cops—Hickey, Ski, Curley, and Ferrari—who actively pursued writers, but most of the other police didn't have much knowledge. Another incident happened when I had just come back from overseas. I had that fever and wasn't thinking. I was motioning—catching tags while the train was in service—and got grabbed. And it was funny because, when I got to the police station, SK 2 was locked up there.

ABOVE Delta 2, Sharp, 4 Lexington Avenue Express, 1984. CENTER Sharp, Delta 2, 4 Lexington Avenue Express, 1984. BELOW Delta 2, Sharp, 5 Lexington Avenue Express, 1982.

When they were bringing him in, he saw me in the cell and was like, "Yo! What's up?" The cop was like, "Do you believe it? It's like there's a whole fucking network." I just remember them asking me what I wrote, but I lied. I told them I wrote "Snarp" because I didn't want to out myself; because if I did, there was always a possibility that the cops who didn't know what time of day it was would call the cops who did, and if Hickey or Ski caught up to you, you were definitely going to have your ass whooped. Hickey, Ski, Curley, and Ferrari were notorious for that.

Curley and Ferrari's specialty was to lie in wait for writers in the lay-up, in the conductor's booth at the center of the train. When a writer got into the car and started to do the insides, they would wait until he got to the middle of the car and then come out of the booth, without saying a word. They'd close in on him. Once they took this kid's marker and shoved it down his throat. If you think about it, they could have killed him. That guy never wrote again. If you look up graffiti deterrent, you'll see that there were a whole bunch of dudes who ran into them and never picked up a marker again because they would terrorize people no end.

There was this one time when Seen dropped a dime on us because that's the way he and this crew—kids like Jam 2 and Breezer—used to roll. On the 6 line, there was an abandoned hospital where they used to hang. From there, they could see when someone went to the lay-up and would send emissaries. The emissaries would be like, "Yo, what's up?" They'd be talking to you while you painted and be signaling to the people in the hospital. Dudes would disappear; you'd think they were doing the insides, and then you'd be raided. So you'd run to the pole and slide down. Usually there would be a particular point along the track from which you'd want to slide. Then, when you got down to the street, you'd end up in an Italian neighborhood, and they'd be like, "Get those fucking niggers!" And then we'd have to run again. Every time we painted trains, we were always in enemy territory because we were from Manhattan. And there were no lay-ups in Manhattan except in the winter, when it snowed.

I know people were snitching because, later on, me and Dust became boys. Dust was on the run: he had caught a case in New York, so to avoid the long arm of the law he had gone to California. And I was out in California trying to kick a dope habit and fight a case that I had caught out in New York. I was out there, he was out there, and we'd get into mischief. I started asking him about different episodes and talked about Seen. We had bumped into those guys when we were painting. But that was just the way the game was played. Everybody was trying to control their real estate. If you went to New Lots in Brooklyn, you had to deal with a certain group of people. If you went to the 6 line, you had to deal with the UA. That's just the way it was.

When I got caught in Brooklyn that time, the charge was trespassing and I got a $75 fine. The other time I got caught motioning, I had to scrub trains a couple of Saturdays for four hours each time. It was '85 and the end of my writing career. Scrubbing trains was very sobering. They'd give you two buckets of acid, some rubber gloves that went all the way up to your shoulders, and a Brillo Pad. If you can imagine being underground in summer—the heat, the smell. No fun. You'd get there, they'd hand out the gloves, and there would be 5-0 there. So if you didn't clean that shit, you'd get arrested right there. You'd have writers or fare evaders or other types of offenders there every Saturday, and there would always be a few people who'd be like, "Fuck this shit. I ain't doing this shit." Click—they'd take them away.

The scrubbing was the beginning of the end. The actual day that I hung it up, I was supposed to meet Delta in the winter lay-ups. He didn't show up, so I went and did my piece anyway. I just remember being in the tunnel and feeling fear start to creep in. They had just changed the law: if you were a second-time offender, you'd be looking at a mandatory two weeks at Rikers. That was when dudes started getting hit over the head for graffiti. Before that, you'd get a really small fine or smacked upside the head or kicked in the ass. But when they started locking heads up on the Island, it was definitely like, "Yo, this is too much." Plus, by that

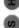

point, I had already figured on a professional art career, and it became difficult to see the merit in all the risks.

There is a big difference between people who write and people who are king of the line. To be a king of the line, that's like a full-time job. For two years straight, we'd go to school as little as possible, we wouldn't have girlfriends, we were just like "eyes on the prize." Days spent shoplifting and taking pictures. Nights, painting. We were mad surgical. Every day, we'd hit different lines. I had a few traumatic raids and shit like that, and eventually I was like, "Fuck it. I've had enough of this." Delta got electrocuted one time, and me too on another occasion, although not as badly. Enough was enough.

As far as painting specific cars, what stands out in my mind are the times I got raided—or when moments were protracted for some strange reason. Feelings would be heightened. I remember doing a window-down with Kase 2 and spending two hours inside the trains as he chose the color scheme. I remember just thinking that this was taking *waaaay* too long. The air felt thick. I remember times with G-Man because he was disabled and would just stay on the platform usually, although sometimes he'd go onto the tracks. And whenever he came on the tracks, because he was on crutches, I couldn't breathe because I always thought that one of his crutches was going to go through the wood and he was going to fall. He couldn't do his own pieces, so we'd do them for him. He'd go to the store and get burgers and beers.

With graffiti writers, there's a level of dysfunction because a large part of the motivation, or I guess the catalyst, was the fact that we were all sort of like outsiders or problem kids or something like that. It was just a hodgepodge of different people and different socio-economic and racial groups. But that was the thing about writing: it was the one thing on a lot of levels that crossed all over those lines. There were people writing who came from privileged families; and there were others who came from nothing. I always thought the idea that writing is something that came from the ghetto was one of the biggest false perceptions. I mean,

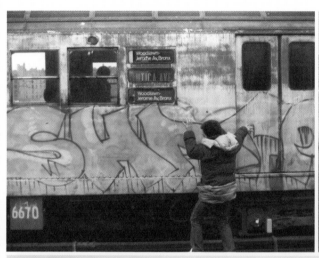

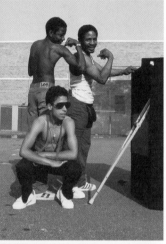

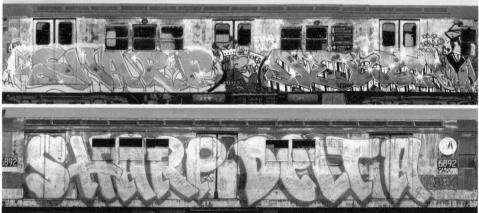

ABOVE LEFT Sharp on the tracks, 4 Lexington Avenue Express, 1983.
ABOVE RIGHT G-Man and friends with homemade speaker, Bronx Park Jam, 1983.
CENTER Sharp, Delta 2, 4 Lexington Avenue Express, 1983.
BELOW Sharp, Delta 2, top-to-bottom, 1983.

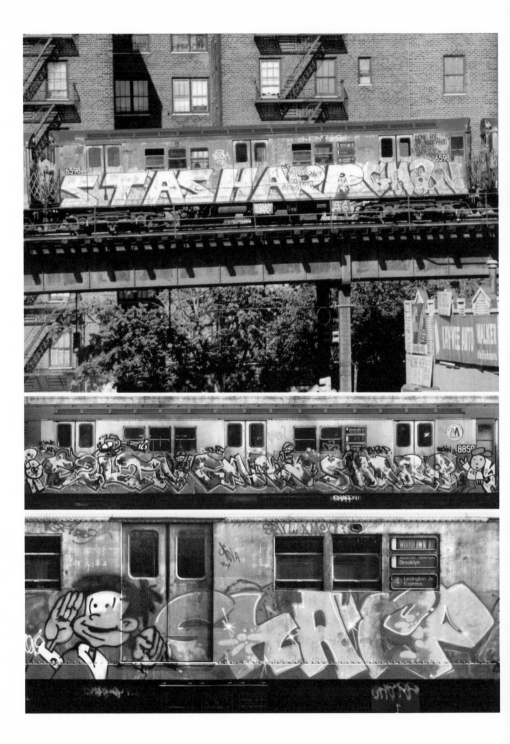

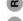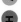

in my opinion, the greatest writer ever to pick up a spray can was a white dude, Billy 167. There will be people who refute that claim, but that's my personal opinion. It isn't necessarily a period of history I was a part of, but the pictures are there. And if you look at who was spawned from Billy's seed, by which I mean Seen, I think Billy was doing something that ultimately would become the blueprint for the letter structure we have today. On a global scale. The idea that writing is something that just blacks or Hispanics from the 'hood do ain't really true.

People from all different places kind of came together with this common goal, and then we all influenced each other and were inspired by each other. When a Duster piece or a Seen piece went by on the 6 line, it motivated us to paint more. We didn't have any real grasp of contemporary art or art history. We were just influenced by each other and inspired by comic art, which in my opinion makes ours the first truly American art movement. People go on and on about Pop Art, but as far as I'm concerned Warhol was completely influenced by the minimalists and Marcel Duchamp, and that shit came from France. So even though he went on to use iconic American imagery like Campbell's Soup, that idea basically came from France. Writers were taking their cue from comic book art, which was made by American Jews. So that's why I think we are the first truly American art movement, hands down.

I'm sure competition played a big part in the evolution. As in hip hop, the whole battle aspect is important because it fuels that competitive streak. But I think on some level, this was the thing that detracted from the movement and ultimately divided people, because graffiti is very ego-based. Drugs were also an integral part of the scene. We were the last generation of hippies in New York. Back then, drugs were all over the place—in my building, in my lunch room, in my community. They

ABOVE Stash 2, Sharp, G-Man, 4 Lexington Avenue Express, 1983. **CENTER** Delta 2, G-Man, Sharp, 4 Lexington Avenue Express, 1982. **BELOW** Sharp, 4 Lexington Avenue Express, 1983.

were always there. And when we started hanging out in clubs and shit like that, they were there, too. Once dudes started making money—teenagers selling paintings for thousands of dollars—the problem escalated. A One would buy dust by the *ounce*. I don't know anyone who'd buy dust by the ounce.

When I was 17, I did my first ever show with Patti Astor. We were only teenagers and were chilling out with movie stars of the day, going to this or that club, or hanging out in the Michael Todd Room at the Palladium. We hung with Madonna and the so-called celebrities of the day. I used to see Billy Idol getting carried out of Berlin every Saturday—Berlin, the after hours spot. Recently, Delta and I were chatting about the old days. My memory is not the best, no doubt because of all the drugs I've taken over the years, but he was telling me about one night when I was in the Palladium arguing with Sinéad O'Connor for like an hour.

My style is a mix of Zephyr's and Delta's that I've somehow made my own. Part of that probably has something to do with the Hebrew alphabet. At a certain point, I started looking at letters and was interested in non-character-based alphabets. Somehow all these influences fused together to produce my style. I don't know if it was any more thought out than that. It just happened, I suppose. But originally, I was like Delta's son. In the beginning, I couldn't do my own outlines; I just filled them in. But then again, that's how you came up. That's how it was before magazines and the internet. If you wanted to learn how to make shoes, you'd go to a shoe store, you'd study. I learned by watching other writers piece. I'd watch them do the outline and then I'd fill it in, and at some point I started doing the whole thing myself. And I got better and better. One of the ways I learned in the beginning was by taking pictures of

FROM TOP TO BOTTOM Sharp, 1 Broadway Local, 1983; Zeph (Zephyr), 5 Lexington Avenue Express, 1981; Delta 2, Sharp, 6 Lexington Avenue Local, 1982; Darizm (Dar), Joey, Delta 2, 5 Lexington Avenue Express, 1984.

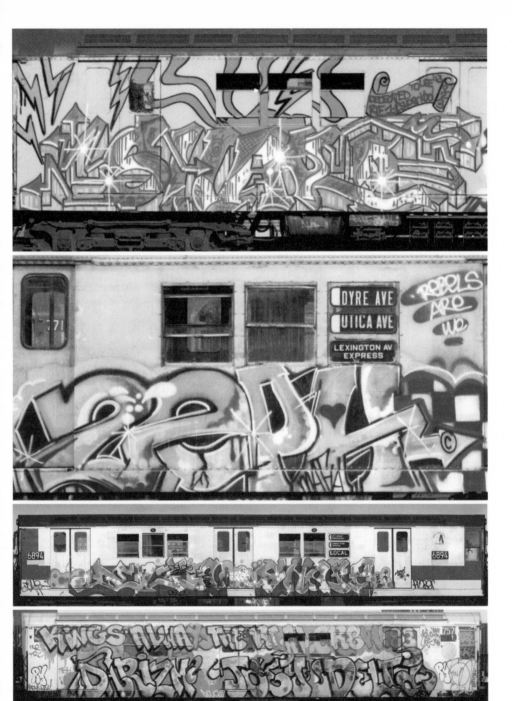

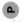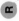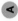

Zephyr's pieces on the wall and then drawing them out. That taught me structure and technique.

Me and Delta lived in the same neighborhood. I knew this writer named Dar who knew Delta, and I wanted to meet him. So I asked Dar, "Where's he at?" And he was like, "Yo, he be hanging out in this game room." I started going to the game room every day after school, waiting to see if he'd show up. It took like two or three days for him to show his face. I was like, "Yo, we should team up and shit." But at that time, you know, he'd taken an ass whooping from his pops, and he wasn't into it. You needed to go with somebody, and the only other dudes I knew who'd been to the lay-up were Brim and Mack, who wouldn't take me because they said I was a toy.

When the trains were no longer an issue, that's when it was over for me. When the wave of people doing thematic murals came along, it felt like a different chapter. For the people like me who wrote on trains, it was all about the trains. People didn't write on the street—that shit came later. Yeah, there were some walls here and there, but if you didn't do trains, you were a toy. There were a couple of dudes who didn't do trains and only tagged on the street. Some of them had respect because of their style, but for the most part dudes who didn't paint trains were toys. That's just how it was.

The global movement—that's an amazing thing when you think about the fact that two hundred kids spawned thousands and thousands of writers the world over. In terms of what the movement or culture has become, it's a double-edged sword. There's the aspect of it that is interesting and fascinating—that we've criss-crossed the globe and enjoyed a whole wealth of opportunities to travel to other places and experience different cultures. Then there's the part of it that I suppose becomes over-commercialized, where people outside of the culture are redefining the movement based on their own financial desires. Just as previous artistic trends were co-opted by a particular sector of society, the same thing is happening and has happened with our movement and, you know, that's

just part of evolution. Probably the saddest part about it is the way we've all been pulled apart because of money. You know, ideologically, wherever there's money, there's blood on the floor. And that's just the way it goes. Part of life.

One good thing to come out of all this is the fact that our work is in museums and private foundations, and our paintings will live long after our physical bodies have ceased to exist. Look at Van Gogh: he made nothing from his art in his lifetime and lived as a pauper—and probably with a considerable sense of sadness because he died without knowing the reverence and accolades that would come later. I think it was Jon One who said, "If you ain't selling your work, it doesn't mean shit." It's subjective.

People did well, but there were slow periods from the mid-1980s to the early 1990s. Futura was a messenger. Crash was towing cars. I was in an extreme drug haze. By the early 1990s, many of us had realized that we were artists and wanted to pursue art careers because it had started to bear some fruit. So then, you know, I thought I might as well go live in Europe because the people collecting the work were there, and the opportunity to live a different life was really enticing. I credit European lifestyle and culture with making me human. As an adolescent growing up in New York, there was a lot of violence and negativity in our communities. On the European front, people were telling us something completely different from the powers-that-be over here. In the beginning, we hadn't had any encouragement from institutions, our parents, our neighborhood. It wasn't uncommon for people in the neighborhood to be like, "Yo, I should knock you out. Stupid motherfucker, fucking up those trains." Many years later, the same people would be like, "Yo, that's my man! The ghetto European! What's up?"

SKEME

Most folks know Skeme from the film *Style Wars*: his exchange with his mom in the family kitchen is a classic moment in hip-hop history. Skeme's style was both hard and soft, sharp and round. The letters in his pieces were also a reflection of his tags—something that endears him to the pioneering generation of writers who blew their signature letters up and out over time. When non-American writers and scholars of the culture think "ultimate write," the name Skeme lights up their foreheads.

y first experience of graffiti was when I was 12. I used to go to Camp Little Saint on 143rd and Lenox. There was a sleep-away camp they were connected to, where you went for the summer. You stayed in these cabins that were bombed with what I now know to be graffiti. At the time, I thought it was just camp kids writing their names. Some were a little more detailed and stylish than others. As I had been drawing since I was 8, the writings piqued my interest. So I started writing my name at camp. Before I changed my name to Skeme, I would just write my surname, Dash, on the canvas cots and wooden walls. That was my real introduction into graf.

Through the camp experience, I met a very good friend, a dude named Robert. He had a secret: he was a graffiti writer. One day, after school, we were just chilling at my house. I was writing "Cheerios" at the art table I had in my room. Peering over my shoulder, he asked what I was doing, and I said that I was writing graffiti, like I was telling him something new. He just started laughing. I don't know what the word for "wack" was back then, but whatever it was, that's the word he used to describe my shit. I said, "Who are you to tell me my shit is wack?" "I write graf," he replied. "I'm Mr. Mean and I'm down with TMT."

From that point on, he started schooling me. The first thing he told me was that Cheerios had to be the wackest name he'd ever heard, and he helped me come up with alternatives: "How about Skeme? Because you're always scheming on ways to get money." Back then, I used to go "money racking" all the time: we would go to outlets and steal aspirins and Spam, coffee, Tylenols, razor blades, bring them back to the 'hood and pass them on to the bodegas, which then sold them. The first time I wrote my name, I spelled it the regular way—Scheme—but Mean told me that "the dope writers' names don't have more than five letters. It's five letters or less." That's when I changed the "ch" to a "k," and Skeme was born.

Graffiti culture was a secret among writers, and writers knew each other's work. The public didn't know what they were looking at; all

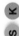

they saw was a scribble. I use the term "scribble" because it's one of the reasons old-school writers don't like the word "graffiti." They consider it a derogatory term because it derives from the Italian word for "scribble," "scratch," or "scrawl." It's taken in a derogatory way, but I came up when it was called graffiti. There was no such thing as "aerosol art" back in 1981, and no one would ever have called themselves an "aerosol artist" in the early 1970s. Aerosol artist is a relatively new term that some people use to describe a graffiti artist, but I don't want that title. You can take a can of spray paint and put a kitten on the wall. Just because you're using aerosol, it doesn't make you a graffiti writer. I'm a graffiti writer.

In a certain sense, you could draw a parallel between the use of the words "graffiti" and "nigga." Both have been considered derogatory terms, but we have taken these words and turned them around so that we own them; for some, they have become terms of endearment. Among black people from the south of the USA, where experiences of racism have been different from those in the north, and still are, there is often a different response: a lot of them cringe when they hear the term "nigger." But there is a distinction between "nigger" and "nigga," and the bottom line is that it's part of our vocabulary growing up in the 'hood and we don't mean anything derogatory by using it.

In the early 1970s, writers took a tag—or what was called a single hit—then took another color, and outlined around that. Gradually, this form of expression evolved: lines got thicker, fatter, wider. That's exactly how so-called masterpieces were developed, from tags. In the 1980s, some of the most magnificent works of art rolled by right in front of you; you had a front-row seat to a free art show. Before I became a writer, I used to wonder who was responsible and how they were doing it. You had more sophisticated guys who started drawing actual cartoon characters. How did that guy get Mickey Mouse on the train? There was a whole lot of wondering before I met Mr. Mean.

I started on the insides. The very first time I wrote with Mr. Mean, he took me to the 1 lay-up on 145th and Broadway. It's funny really, thinking

ABOVE Skeme, Daze, 1 Broadway Local, 1982. BELOW Trap, Skeme, Dez, 1 Broadway Local, 1982.

back: the 3 yard was right next to my house, so it's kind of surprising that it wasn't the first yard I went to. The car we went into was all lit up and was right in the middle of the station—not even in the tunnel. It was really bombed: you literally had to fight for a spot. I remember when Mean wrote his name and the drips just came down—I almost bust a nut! I took my first tag in some crazy-looking, wack style, I'm sure. When the drips came down, I was sold. I went on to bomb the insides of the 1s, 2s, 3s, 5s, As, Cs, and Ds.

One day, Mr. Mean says, "I want to take you to meet somebody." We get on the train, ride up to the Bronx, go into some projects, and knock on some dude's door. When the dude comes out, Mean tells me, "Yo, this is Phase 2." Being the super toy that I was, I had no idea who Phase 2 was. I was like, why am I here meeting this dude? Little did I know that Mean was educating me, and it wasn't until a year later, when I started hanging around writers more, doing research, asking questions, and listening to people talk, that I realized he had taken me to meet the Jesus of graffiti and I hadn't had a clue. My introductions to graf were good!

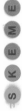

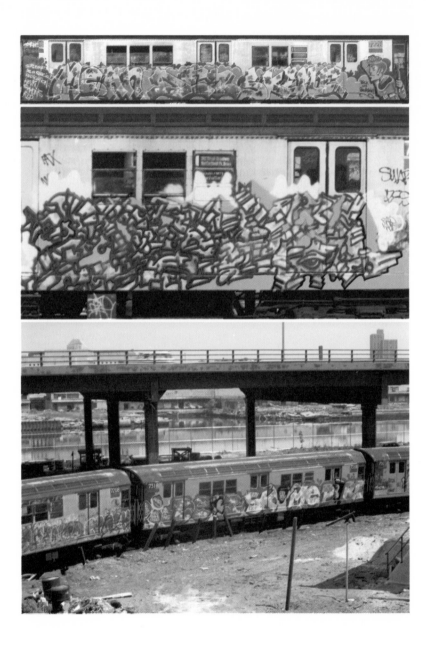

I hate to use the term "segregation" because it has negative connotations, but it's not true that yards were integrated. Some yards were neutral, some were black yards, and others were white yards. I've never seen a white person in the 3 yard. I'm talking about my era, between '80 and '82. It was the same with MPC's area up by where Cap [who was a member of MPC] lived: those were white yards. It may not have been intentional: there weren't black dudes from the 3 yard barring white dudes from entering. It was more geographical than anything. If you had a yard in your own backyard, why would you travel miles to come to the 3 yard? The 1 tunnel was a multicultural tunnel, if you will. You had RTW (predominantly white), TVS and TMT (black and Hispanic), and TFP (predominantly black) haunting the tunnel. In the early 1980s, you also had the Ball Busters, a Dominican group of cats. The tunnel has undergone a facelift in terms of ownership: from white to black, to white and black sharing, to Dominicans almost taking it over from '81 to '82, although that was more to do with gang culture than writing. Most of the Ball Busters didn't write. Of the few that did, Baby Rock was known to take a couple of hits on the insides, and Airborne was a dude who actually did pieces.

Whenever I went to the tunnel, I had no problems with those dudes. They would see me and say, "What's up?" In fact, around thirty FBA/Ball Buster dudes once came to the 3 yard and were there when we got raided—one of my most memorable raid stories. We kind of shared those yards and had no issues. I was there when the Ball Busters grabbed Rasta. I have to say, I hated that because I'm not a vamping dude. I don't mess with other people, never have. I just happened to be walking down the tunnel at the same time as the Ball Busters. Rasta was looking at me like

ABOVE Mean, Dez, Skeme, 1 Broadway Local, 1982. **CENTER** Phase 2, 1 Broadway Local, 1983. **BELOW** Dez, Skeme, Pore, train leaving the 3 yard, Harlem, 1982.

I was with them, but I wasn't. They beat him down and took his paint, but Rasta had some balls and followed them. I tried to give him a look as if to say "Leave it alone and just paint," but he kept going and they stomped him out. When I saw him on the train a couple of months later, he just looked at me. I felt bad because he thought I was with them.

I didn't go to MPC areas, not out of fear, but because I had spots I liked to hit, like the 2s and 5s at Gun Hill lay-up. We had an issue with those guys and I don't really know how I ended up getting involved. Cap had a problem with everybody in Harlem, the Bronx, and Brooklyn. One night, me and Agent were sitting at my crib and the phone rang. It was Terror saying that Cap wanted to know if our crew, TMT, would be interested in a truce. Me and Agent discussed it and went to see what they were talking about. We got a few "little things" for safety and rode up to meet with Cap. We had a common enemy—CIA—and that's how the truce between TMT and MPC came about. I know that one of the cars me and Kool 131 did looks crazy because Cap only went over the "Kool." Why didn't he go over the "Skeme"? Cap was like the majority of racist people, white and black. When you talk to them, you realize that they're nothing more than a product of their environment, with a fear and misunderstanding of other people. To use strong language: you can't be a nigger-lover if you come from a neighborhood that hates niggers. You have to fit into the neighborhood you live in. I truly believe that's how Cap was—all of that stuff about how "niggers know," the infamous line he dropped in *Style Wars*. I don't believe that dude is a racist in the truest sense, but he is a product of the environment he lived in.

TOP LEFT Cap doing a throw-up over Blade, 180th Street train yard, 1982. **TOP RIGHT** Agent TNT outside Fashion Moda, *ca.* 1982–83. **CENTER, FROM TOP TO BOTTOM** Skeme, Agent, 1 Broadway Local, 1982; Skeme, Kool, Cap throw-up over Kool, toy over Cap, 1 Broadway Local, 1982; Spade (Dez), Skeme, Kool, 2 Seventh Avenue Express, 1982.

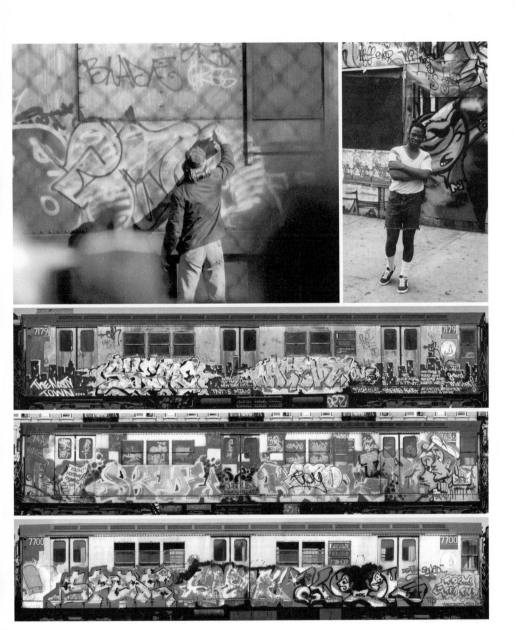

Pain 1 was one of my best friends, and the whitest of white Jewish dudes you'll ever meet. I had white friends, so I see race differently. I don't judge people by their color, but by how they conduct themselves, by their character—that Martin Luther King shit. I didn't grow up focusing on race, but I do understand the separation and racial issues. TMT was not a discriminatory crew in that sense. It was made up of Hispanics, blacks, and white guys like Fuzz 1. If we did discriminate, it was based on style and getting up. We were looking for a certain type of style, and if your style didn't fit those parameters, we weren't interested in you and wouldn't accept you.

If you looked at Fuzz's pieces, as a white dude, his shit had a little flair to it. But a lot of white dudes didn't have it: their style was less rhythmic, a little stiffer, and largely based on straight letters. Only a couple of white dudes broke the barrier—writers like Billy 167. Say you have a couple of white friends but only one of them can dance: it's the same thing with writing. Some white dudes had the same feel to their work as the black dudes, and it came across in their art. Billy was an example of that. If you looked at black and Hispanic writers, you could see the difference in painting and color choices reflected in their work. Take Mitch 77's stuff, for example: I don't mean this in a derogatory manner, but it has a Puerto Rican look due to his color choices, and perhaps also the patterns and influences when he was growing up. I'm not saying one is better than the other, just that I can see differences in the way distinct racial groups painted back then.

Today, the lines are blurred because so many people have access to the internet. You have dudes of whatever color—black, white, red, green— who have access to thousands of photos, all from the comfort of their own home, and experiment with all kinds of styles. This is why we have so many hybrid styles these days, because some of these guys take an arrow from writer A, a break from writer B, a seal from writer C, a shell from writer D… Put all the different elements together, and what you get is a hybrid. You can't tell what color the dude is because he has borrowed

bits from all over the place. These days, if you were to put five pictures in front of me and ask me to single out the black dude or the white dude, I would have a hard time trying to work it out. In fact, I don't think I'd be able to tell. Thirty years ago I would have stood a chance, but not today.

Hip hop isn't about color: it's about performance. No one gives a shit what you look like if you can't dance. But if you can dance, the crowd goes wild—even more so if you're a funky white boy who can dance, because it's not expected of you. Try to imagine the first time that people heard Jimi Hendrix play: jaws hit the ground because black guys weren't known for playing electric guitars that way. Hip hop is universal—something that is embodied in the Universal Zulu Nation, a grassroots international hip-hop awareness group that represents people from all walks of life. You could call hip hop the poor man's sport because it doesn't cost a thing to get a piece of cardboard and flip on your head. You don't need to pay $25 an hour for studio time: you and your homies can get a couple of quarts of beer, stand around a park bench, and rap. I grew up just as rap was making its mark. Where I lived, I was lucky enough to witness all those different influences—fashion, graf, rapping, DJing, B-boying—coming together to form one entity. You would go to a jam and see a dude with graffiti painted on his Lees, so these elements became tied together.

I've been blessed by so many of my hero writers. Someone once asked me, "How do you know when you're dope?" I explained that, back in my day, Kase 2 wouldn't just walk up to you and say you're dope. First, he's Kase 2, and second, it just doesn't go down like that. You know your shit is up to par when Kool 131 says, "Let's do a car." When I first started writing, never in a million years would I have imagined doing a piece with Kool 131. He was a LEGEND when I was first starting out. I'd heard that he was dead, but he'd gone into the army. When he came back, he said he was watching the trains, and watching me, and wanted to do a car with me. I cannot stress enough the significance of that car for me. It was a blessing: in asking me to do a car with him, he was legitimizing me. This was a dude who was the founding father of the Death Squad, one of

the most notorious style crews. If you've got the president of the Death Squad putting you down with Death Squad, then you're legitimate.

That car with Kool 131 (p. 135)... I remember there were all kinds of colors: delta blue, baby blue, red, dark gray over the character, beige, tan. The dude on the left is a reporter, and if you look at it closely, you'll see that I put a card in his collar but misspelled it. I put "Prps" and people thought I meant "prez," as in president. I meant to write press! We were probably high. He also has a microphone and is reporting, and next to it you'll see a scroll that says "Mercenaries Return." A lot of people don't know what it says because we tried to squeeze it in there. That's the kind of shit you do when you're high. If you weren't high, you would just try to redraw the scroll bigger to make it fit. The Mercenaries: you might want to talk to Kool about that, but I think they were a group of cats who had nothing to do with writing. They were some hustling cats who lived up his way, in Manhattanville projects on 131st and Amsterdam. Don't quote me on that, though. On the other side of the piece, you have two characters who are supposed to be me and Kool holding up two identification cards. I've heard a lot of bullshit, people saying I got my characters from Kool, but they came straight out of my head. Those characters are me and Kool.

The *No Nukes* car (pp. 140–41): that was Agent's idea, and it came from the 5 Percent Doctrine. In the 5 Percent Doctrine, you have the Supreme Alphabet. Each one of those words means something, and then you would do what was called Build and Destroy. One of the common practices was to take your name and break it down into an acronym. It was during the time of the Cold War, when we had all these scares, that Agent came to me. Originally, his name Agent broke down to "Allah Generates Energy Not Trick Knowledge," but for this piece he broke it down to "America's Got Enough Nuclear Troubles," which of course spells out Agent. That's how the car was born.

The Skeme/T Bag car from *Subway Art*: that was another blessing, one of my first exposures to what is called the "diamond-point style," a simple, funky letter style that was made up and perfected by Chain 3 on the handball

court in the back of the 3 yard. When I saw Chain 3's piece, I just stood there for an hour staring at it and studying it. It looked like it was peeled off the pages of a comic book. That's how expertly it was drawn—no tricks or nothing. It was before I knew who Chain 3 was, so again I was watching all these cars: the Chain with the "Sir Nose" character, the Chain and Kools. I was like, "Who is this Chain 3 dude?" When I became a member of TMT, I eventually met him—another blessing. For Chain 3 to get on a car with me meant everything. When we painted the Skeme/T Bag car, it was Chain's birthday. That car was done with garbage paint if you look at it. I've used copper for my fill-in. It's not a coveted color, but I had one or two full cans of it. If you look at the image closely, the colors are really crafty. They were just scrap colors—leftover paint I had to hand. As well as copper, I used flat black and I think I had just enough gray and green and red to make the cloud that goes round my shit.

The *Strictly Skeme* piece (pp. 140–41) was a married couple (which means the cars are connected together forever) next to a *Secret Agent* piece. Agent did that standing up on an elevator at Gun Hill lay-up, on the lower tier. We did that in the middle of the night. Age had a dope name because there were so many things you could do with it. "Secret Agent" was one of the best and one of the most obvious. Since he had "Secret Agent," I had to come up with something cool, so I chose "Strictly Skeme" and that's what inspired that car. I remember that night, before we broke out, we stopped on the platform. I started doing a beat and Age started rapping. We must have stood there for thirty minutes, making rhymes and kicking beats—right there on the lay-up. But we didn't get caught. No one even spotted us.

I'm glad graffiti is alive and well, and people are still writing. Still, I feel like the old dude who has slept with eighty women, then tells you that you should find Jesus and stop hanging out, smoking, drinking, and writing. Some countries have seriously stiff penalties, but you've got these young kids trying to emulate what we did in the 1980s. That's cool, but the laws aren't the same. The terms aren't the same as back then. We only faced class C felonies or misdemeanors. Today, you're looking at a class A

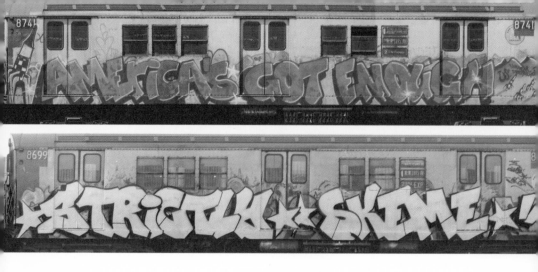

felony for trespassing in a train yard. Access to a train yard is tied into homeland security. If I can get into the train yard to paint, that means terrorist A, B, and C can get in to plant bombs. If I can get in to paint, the transportation system isn't secure. The public needs to feel safe, so we can't have kids getting into the train yard. After 9/11—and then all of this foolishness with assholes blowing up kids in Boston—things changed.

Graf is a virus for which there is no cure, and it's not going anywhere. When you see it on shoes, clothes, furniture, architecture, you know it's mutating and you can't stop it—just like hip hop.

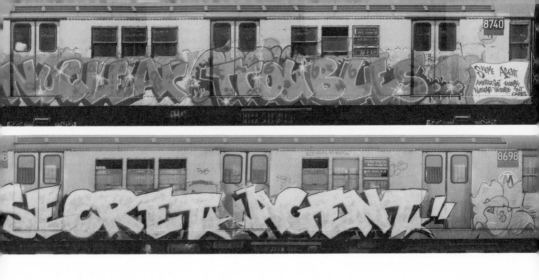

ABOVE *America's Got Enough Nuclear Troubles* by Skeme and Agent, married couple, 2 Seventh Avenue Express, painted for the anti-nuclear demonstration in New York City in 1982. **BELOW** *Strictly Skeme Secret Agent* by Skeme and Agent, married couple, 2 Seventh Avenue Express, throw-up by SE 3 on the right, 1982.

SPIN

The original Spin probably quit writing in 1974, but *this* Spin really went hard from about '80 to '85. He had the distinction of painting the *Dump Koch* piece that was reviewed by Mayor Edward Koch in Henry Chalfant and Tony Silver's documentary *Style Wars*. Spin's nerdy leanings would lead him to the computer programming world in which he currently towers. His recollections as a geek obsessed with graffiti is proof positive that writing can help an individual leap from unassuming kid with dreams to swashbuckling superhero fortified with colorful means.

When I was a kid, maybe 4 or 5 years old, I lived in Brownsville, Brooklyn. I remember seeing tags and some skinny letter pieces on the outsides of the elevated 2 train that passed through my neighborhood. I don't recall any names, but it must have been whoever was hitting the 2 line back in the early 1970s. I didn't think much of it; I assumed that's the way trains were supposed to be, with stuff drawn on them.

When I was a little older, we moved to East Flatbush. There are no parks in East Flatbush, so when my friends and I wanted to play ball on real grass, we had to walk up the hill to Lincoln Terrace Park. A bunch of MTA employees would play baseball in that park every weekend. Sometimes we would play ball ourselves, and sometimes we would just watch them. The 2 train would come thundering out of the ground onto the elevated tracks right next to the park, and my friends and I would always stop to look. It was impossible not to. There were more paintings on the trains by then, the mid-1970s. There were a few burners, lots of throw-ups, and even a few top-to-bottoms. I don't remember names from then either, but I was old enough to know that it was called "graffiti," that kids were doing it, and that it was against the law. A few years later, when I became a writer, I understood why so many MTA folks hung out in that park and I ended up spending a lot of time there myself, for a different reason.

I'm a product of the 1970s. I watched way too much (bad) TV—*The Six Million Dollar Man*, *Land of the Lost*, *Fantasy Island*, and *Good Times*, to name a few. I got hooked on comic books. My favorites were the *Hulk*, *Spider-Man*, and the *X-Men*. I was strictly a Marvel kid and really got into the work of artists like Ernie Chan and Sal Buscema. At the time, I couldn't stand Jack Kirby's artwork, although this changed when I got older and learned to appreciate his stylized look and "heavy" inking. The only time I bought DC comics was when Neal Adams was the artist. I thought Neal was the best in the business; I felt his art had more depth and complexity than other artists.

I was hanging out at my friend's house and there were some comic books on the kitchen table, including a *Superman* illustrated by Adams. My

friend's older brother was a professional illustrator and was constantly drawing and sketching. He picked up the comic and proceeded to re-draw the cover art of Superman lifting a building with his bare hands. He changed it a bit: Superman had a cigarette dangling from his mouth and an "E" on his chest; and instead of a building, he was holding a curvy lady in his arms.

I was totally hooked. How had he re-drawn that cover so effortlessly? He had transformed the squeaky-clean middle-American icon into something different—something he could identify with. I think this is the essence of hip hop: remixing one thing into something else and personalizing it in the process. I wanted to have those skills. I started drawing constantly.

Around the same time, I became interested in electronics, then digital electronics, then computer hardware, and finally computer software. I begged my parents to buy me an early computer called the Heathkit ET-3400. You had to build it yourself, I mean really build it. Each part had to be soldered into place. So I taught myself how to read electrical schematics and how to solder. After it was built, you could program it, write software for it. I loved the fact that I could build things that existed only in my mind; that I could give a soulless machine instructions to make it do what I wanted it to. Art and software became the yin and yang of my teenage life. When I wasn't staying up all night bombing trains, I was up all night hacking. It's a love that continues to this day.

Comic books were the gateway to graffiti and were the reason I was a decent artist when I started at Brooklyn Technical High School. To get to Brooklyn Tech, I had to ride the subway. I started seeing graffiti every day and slowly began to understand the rules and the culture. This was in 1979 and I was 14 years old.

I didn't really have a mentor—I learned the hard way—but two guys did help me out at the beginning. One was a friend of mine from junior high school who wrote "Soro." He got me interested in graf, taught me

the basics, and helped me to bridge the gap between comics and graf. I realized intuitively that graffiti was a meritocracy. I didn't need anyone's permission. I didn't need to belong to a particular social or racial group. Graffiti transcended all of that. All you needed to do was get out and bomb trains. So I did. The second guy was a writer from my neighborhood called C.R. Tony who took me bombing that first time. I begged him to take me out. We went to the Kingston Avenue lay-ups, where trains were parked during the day, between the morning and evening rush.

On that first attempt, I tried to transfer everything I knew about comic-book art—about working with pencils, inks, and Design markers— to the side of a subway car. It didn't end well. I didn't understand the medium. Spray paint is not ink. If you don't know how to handle it, it drips. I didn't understand how to pick colors properly so that the background and foreground contrast. So I ended up with a dark green, ugly, drippy piece. But that ugly piece ran through the entire city—all the way

Spin, 4 Lexington Avenue Express, 1982.

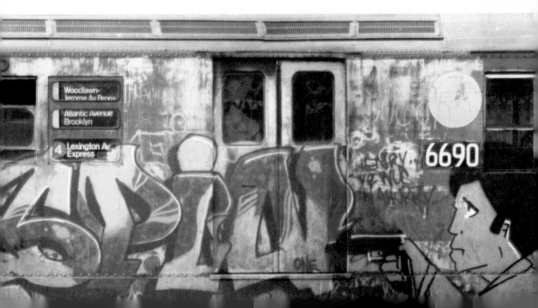

from New Lots Avenue in Brooklyn, up 7th Avenue in Manhattan, up to 241st Street in the Bronx. I decided to try again.

I had some toyish names at first that I don't even remember. Then I started writing "Spinner" as I was into DJing at the time. "Spinner" kind of stuck, but it was too long to write, so I shortened it to "Spin." I asked my graf friends if the name "Spin" was taken. They told me it wasn't, but actually it was, by a writer who was active in the early 1970s. So I wasn't the first "Spin," but I did get the name up—a lot. Later on, I started writing "Kool Spin" to avoid any confusion.

My parents HATED graffiti. I went from being a straight-A student to a semi-dropout. Correlation does not imply causation, but my parents didn't understand that. They blamed graf. The truth of the matter was that I was fucking bored. School, even a specialized school like Brooklyn Tech, was way too easy. Once, in my digital electronics class, the teacher saw me falling asleep at the back since I had been up late the previous night. Thinking he had caught me out there, he asked me to come to the board and do some base conversions between binary and hexadecimal. As I was already programming, it was a piece of cake. I wrote the answer without doing any of the intermediate steps that he had taught the rest of the class. I went back to my seat and closed my eyes again. Yeah, I was a jerk, but the entire class was stunned. He never tried to call me out again. But even with my horrible grades, my parents were very liberal with me. They always encouraged me to find my own way and never tried to force me into doing anything I didn't want to. I think they ultimately kind of looked the other way while I explored graf.

As far as graf-world influences, I would say Skeme, Dez, Lee, Dondi, Zephyr, Rasta, and Seen UA were at the top of the list. Later on, I became a huge fan of Kase 2. He brought cubism to the world of graffiti. He definitely influenced my career in the later years and inspired me to come up with my own version of cubism. RIP Jeff Brown. Outside the graf world, I really looked up to my uncle, Bruce, who is a professional architect. Great-grandfather Steven was a bona fide hacker, from all the stories I've

heard about him. For example, he rigged up a device for catching the mongoose that was killing the chickens at his farm in Jamaica. Maybe I get the hacker gene from him.

A piece starts with an outline or a sketch. Some writers use very detailed outlines with all the colors carefully laid out, but mine was just a quick sketch. It's really all about the letters, so you need to change them up every time. Otherwise you end up doing the same piece over and over again, and nobody wants to see that. You've got to make your letters dance. Formal art training, which most writers don't have, is really helpful here. Composition, color scheme, white space, line, texture, shading, accents—most writers pick up these concepts through experience. Then it's time to plan the execution. What train line will it run on? Is it a solo piece or with a crew? Is it a panel piece, window-down, or full car? How long will it take? How many cans of paint? These are all things that need to be taken into account.

Then it's time to get out of the house without too much hassle from the folks. I liked piecing late at night, so it meant leaving the house around midnight. Living in a house, rather than an apartment, made things easier. I would just chill downstairs watching (bad) TV until I knew everyone was asleep, then quietly open the door and be on my way.

Sneaking on the subway with all my cans of paint was dangerous: if a transit cop grabbed me, they would have me for beating the fare and also for my "graffiti implements." Transit cops hated graf writers because we made them look bad, like they weren't doing their jobs. Luckily, I knew which stations had the transit cops and which didn't, and also where they would hide. And even if a cop did pop out of nowhere to try to grab me—come on, I was a teenager in top physical condition. There was no way some overweight, middle-aged cop was ever gonna catch me.

My favorite night-spot was the Utica Avenue lay-ups. The MTA would keep two sets of 5 trains there for the whole weekend. It was also a quiet spot that not too many writers knew about. Kids like Web, Tekay,

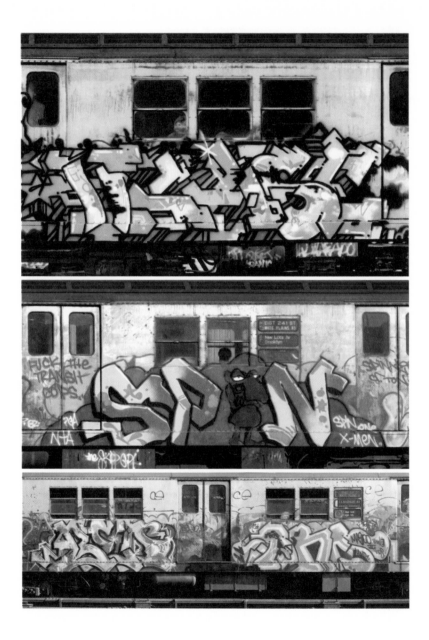

Myzer, Magoo, and Hash would go there, but these were all writers I knew and was cool with. (I actually went to day camp with Web at the Flatbush YMCA when we were both comic-book-crazed kids.) Going into the lay-up from the platform was a bit dangerous. There were control towers in the tunnels at Utica Avenue, and you never knew who was in there. So I would leave the subway and enter the lay-up from Lincoln Terrace Park (remember that spot?).

In the early 1980s, if you went to Lincoln Terrace on a Saturday night, you would find it buzzing with activity. It was wall-to-wall with hookers practicing their trade. So my young, innocent ass would have to walk past dudes getting blowjobs on the park benches, people just straight up fucking, etc., etc. I would walk over to the spot where the train came out of the tunnel, the same spot where I had played baseball and admired the trains as a kid. I would glance around to make sure no one was paying too much attention to me, then climb up some high-voltage cables, over the service gate, and down the tracks into the lay-up. I've got to say, this walk down the tracks was a real coming-of-age experience for me. My adrenaline was pumping. I had a bag of paint in my hands, an outline in my back pocket, and a real purpose. I felt like a man. But it was also the most dangerous point in the night. I was out in the open, visible to anyone. If the Vandal Squad had bagged me, they would have given me hell as my name was all over the subway by then.

In a few minutes I would be underground again, in the dark safety of the lay-up. The first thing I would do was to check out the place. Did I hear paint spraying? People talking? Were they writers? MTA? Cops? If all was clear, I would walk over to the piecing spot. This was a bend in the tracks where you could actually step back a few feet from the train to look

ABOVE Kase 2, 1 Broadway Local, 1980. **CENTER** Spin, 2 Seventh Avenue Express, 1982.
BELOW Bed, And (Magoo), 2 Seventh Avenue Express, 1982.

at your piece. It was also next to the emergency exit, which led upstairs to the uptown level and finally up to the street. I would break out my can of Olde English, have a seat, and drink it down. Yeah, I used to drink that swill: it was cheap and I was broke.

After I got my buzz on, I would break out my outline and start planning my piece. You have to compose your letters properly: you want your name spread out evenly, with all the letters of the same size, according to your outline. Once you can mentally visualize your piece on the car, it's time to start with the rough outline. There was only a dim service bulb in this part of the tunnel, so I needed to use a color like white that stood out from all the static (old graffiti and subway dirt) and gave me an idea of what my piece would look like. It's OK to sketch a bit with the paint at this point. You can even make changes to what was in your paper outline. I did this a lot, just coming up with some ideas on the spot on how to twist my letters, adjust white space, that kind of stuff. After you're satisfied with the rough outline, pop a fat cap on your fill color and start to fill in. The fat cap spreads out the paint, so you can cover a lot of the car quickly. Now is the time to fade your colors together if you like. The fill colors also remove your rough outline, but that's OK because you've mentally visualized what the final piece is going to look like. After your fill is done, it's time to add hook-ups, doo-dads, whatever you want to call it. Those are little designs over the fill color that add some character, variety, and texture to your letters.

Now you're ready for the make-or-break moment. Your final outline can make your piece sizzle—or totally fuck it up. Experience helps here, nothing else. You put a fine cap on your outline color to give you a narrow, well-defined line. Your hand has to move smoothly and evenly, or else you'll get drips. If your hand control sucks, it will look like the outline doesn't match the fill. That's hard to fix and makes you look like an amateur. If you move too quickly, the paint will be too thin and you'll have to go over the line again. By this time, between the alcohol and paint fumes, I would be pretty high. That's a good thing:

it would calm down the adrenaline that was still rushing through my bloodstream and let me concentrate on my piece.

Almost done. Now step back as much as possible and look at the whole piece. It's time to make any last-minute adjustments, but not too many. Then add any final touches, like a message to a loved one or the general public. For a long time, a copyright notice was added, which is clearly very important for legal reasons (seriously, a lot of writers really did this—I think I did too, but don't ask me why). If you have a camera, take a picture. For better or worse, your piece is done and will go on public display during the Monday morning rush. If it's good, fans and haters alike will comment. If it's not, well that's too bad. The train will pull out Monday morning and the entire city will see your skills or lack thereof.

By this point, it was time to leave. It was close to dawn by then, so once again I would walk up the tracks into Lincoln Terrace Park, trying my best not to step on any used condoms on my way out. If the piece had gone well...there's no feeling like it—the sense of accomplishment, the exhaustion, the last of the paint fumes buzz starting to wear off. It is an amazing feeling.

On my way home, I would sometimes run into my mom heading to work. Talk about awkward! She would look me up and down. I would have paint and subway dirt all over my clothes, even on my fingernails. (This was a dead giveaway for an active writer: you can scrub the paint off your skin, but there is no way to get it off your nails without using nail polish remover.) I would wave good-bye to her and she would just roll her eyes. God bless that saintly woman. I don't know how she put up with all my crap during those years!

I was king of the 4 line in 1982. When you king a line, it means you're up more than anyone else. You get instant respect from other writers because you're putting in the work and bombing constantly. Like I said before, the graf world is a meritocracy. The 2 and 5 lines were getting too crazy. There was this big cross-out war going on between Cap and everyone

else. So if I did a piece on the 2 and 5, it would run for a couple of days before getting crossed out. But if I did a piece on the 4 line, it would run for months.

The only other writer bombing the 4s back then was Cope 2. We respected each other, so there was no cross-out nonsense on the 4 line. It took maybe a month or so of daily bombing to king the line. The summer of '82 was when I lived and breathed graf my every waking moment. I was doing Spin pieces, Spin throw-ups, Spin tags on the insides. I also started tagging "Sure." That was the summer I discovered blue supermarket ink and Samuel Underberg's store on Atlantic Avenue, just two short blocks from my school.

As far as tagging, the goal was pretty simple: to get up. It's cool to get on a train and know that you'll see one of your tags on the inside. Also, if you were traveling with a friend or a girlfriend, you could just point to your tag and they would know that you took your hobby seriously. As far as respect for tagging, if you see it for what it is—a form of calligraphy—it makes perfect sense. One of the coolest tags I ever saw? Seen TC5 would tag upside down by standing in the seat and leaning backwards against a panel. So if you took a picture and flipped it, the tag would look fine, but ink would be dripping up instead of down. That was cool. When I started to get up seriously, I would hang out at the Writers' Bench a lot. I would run into Dez. He was really cool, but we never did get to paint together. I would try to bomb with Carl Weston, one of my oldest friends. He wrote San 2 back then, but his mother had him on lockdown. He could never get out of the house, so whenever we had made plans together, I usually ended up bombing by myself. I met G-Man and tried to hang out with him, but he was crazy. He would do motion tags on trains in the middle of rush hour. And he would walk into a supermarket and just start grabbing stuff off the shelves! I guess people were just in shock that this dude on crutches would be so bold. He made me the prez of the Brooklyn division of his crew, PGA, a position I had done absolutely nothing to deserve.

There was the Flatbush crew: Hash TNC, Paulistic, Trim. I probably went bombing with those guys more than anyone else. Paul was such a cool dude and one of the few writers I kept in touch with after graf ended. He was even there when I did my final piece on the subway—a top-to-bottom on the Franklin Avenue Shuttle back in 1986. RIP Hash and Paul. Around this time I came out with my own crew, TFS—The Fresh Shit or The Flatbush Squad.

Then I met Sharp and, holy shit, I couldn't believe his dedication. This was a dude who would go bombing every single day. Graf was his life. When he wasn't bombing, he was thinking about bombing, or going to galleries or doing canvases or black books or sketches. I just couldn't keep up with the guy. He introduced me to a filmmaker named Rii Kanzaki, who did one of the few docs about graf called *Forbidden Rebels* (1984). Thanks to Sharp, I even went bombing with Zephyr and Revolt once. He put me down in his crew, Venerable Intruders.

One day, I did a window-down piece with Sharp and Stash 2 at the Kingston lay-ups. An MTA motorman came early, before we had finished piecing. It was confusing because it was long before rush hour started and way too early for him to pull out the train. We were all just standing on the tracks, trying to figure out what this guy was doing. Then we saw the bottle. Yup, an early liquid lunch. He sat down and started nodding off. Sharp said, "Fuck it, let's finish." So we did, with a drunk motorman nodding off in the very car we were painting. Just as we finished, he woke up and turned on the lights. We decided not to exit down the tracks since it would have been dangerous with the lights on. Instead, we used the emergency exit, which put us in the middle of the Eastern Parkway promenade in the middle of the day. Some old men were sitting on a bench next to the exit hatch. They were quite surprised to see a white dude (Stash), a possible Latino (Sharp), and a possible terrorist (me) come out of a hole in the ground and sit down on the bench next to them.

I did have some beefs. It started with Cap—I'm not even sure how. I don't think I ever went over the guy. I even have pictures of Spin pieces

next to Cap throw-ups, and neither one is crossed out. He was up so much that maybe I did a piece over one of his throw-ups, and he saw the top of his stupid-looking "C" peeking out. I think that's what must have happened. Anyway, next thing I know, he's going over my pieces. Not only that, but his flunkies, like Json, started crossing me out, too—to get brownie points, I guess. I did a full car top-to-bottom on the 5 line and, a couple of days later, saw some Json throw-ups over it.

For a long time there was no way to get even with Cap because he only did throw-ups. But then he started doing some real pieces on the 5 line with Seen UA. So I stomped on Cap's pieces exclusively; I didn't have any problems with Seen. In the end, the cross-out wars were stupid and a huge waste of time, effort, and talent.

The *Dump Koch* piece was a trip. I think the city was just tired of the man. In retrospect, he held the city together during a very tough time. When he came into office, the city was broke and couldn't afford basic services like police, fire, hospitals, maintaining the subway. Jerry Ford told New York to drop dead. It was a bad time for the city, but Koch did his best to keep the city alive, and it eventually recovered. I have a theory that you have to be a real asshole to be mayor of New York City. Let's see: Ed Koch, yes; Rudy Giuliani, hell yes; Mike Bloomberg, yes; Dave Dinkins, no, but he only lasted one term...

So while I can now say that Koch did a great job in general, some of the stuff he did was just silly. The reason why the subways were so bad back then had nothing to do with the graf movement. The city was broke and couldn't afford to maintain the infrastructure—that was the real reason. So subway cars broke down constantly, trains derailed, doors would get stuck, etc. But Koch and Richard "Dick" Ravitch, who was head of the

ABOVE Stash 2, Sharp, Spin, 4 Lexington Avenue Express, 1983. **CENTER** Spin, Cap throw-up over Blade, 2 Seventh Avenue Express, 1982. **BELOW LEFT** *Mayor Edward Koch* by Spin, detail from the *Dump Koch* car by Spin, 5 Lexington Avenue Express, 1982. **BELOW RIGHT** Swan 3, 1 Broadway Local, *ca.* 1982.

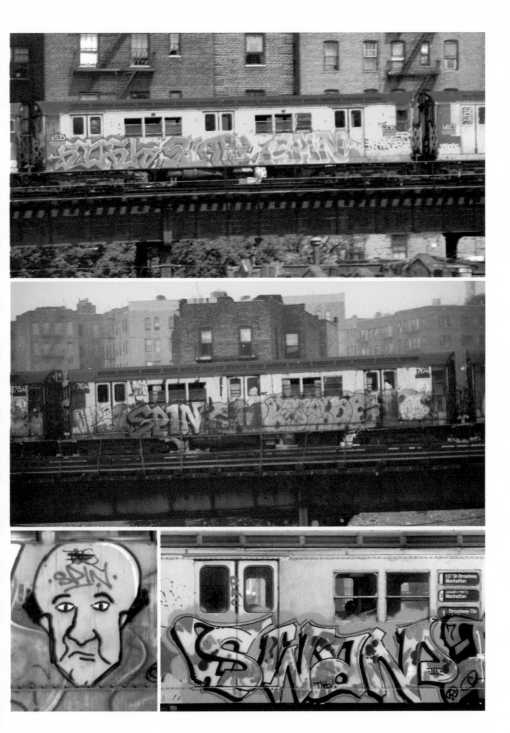

MTA back then, thought it would be a great idea to blame graffiti writers. I guess it was easier for the general public to visualize a graf writer vandalizing the subway system and causing all the problems than it was for them to grasp an abstract concept like the lack of preventive maintenance at the MTA.

That was the inspiration for the piece. I used Red Devil white. Red Devil was the best paint you could get—so thick, it could beat the buff. But I don't think the MTA ever buffed that train. Maybe the Transit Union was tired of Koch too? No one else messed with it either, even though it was on the 2 and 5 lines in the middle of the cross-out wars. Even Cap left it alone.

I loved to hit Kingston lay-ups during the day and Utica Avenue at night. Towards the end of my run, I started going to the Franklin Shuttle and Sheepshead Bay lay-ups too. But nothing could ever beat Utica. It was one of the best places in the city to piece on the 2 and 5 lines. This was back in '82/'83, when I was most active.

The craziest place I ever wrote was on the 1 line, on the elevated lay-up, way up in the Bronx. Carl and I hung out with a writer named Swan 3, a friend of his. I did a piece for his mom in their apartment and later we went bombing. I had never been on an elevated lay-up. There were gaps in the tracks where pieces were missing, so I was holding onto the train for dear life. Meanwhile, Swan, Slin 2, and some other writers from the neighborhood were just walking around the elevated tracks like it was no big deal. The lay-up was right in front of the Marble Hill Houses, and I remember looking around and realizing we had an audience. There were about thirty people from the projects just watching us paint. It was surreal. The next night, I was happy to be back in the warm bosom of Brooklyn, in the proper underground lay-up at Utica.

I started slowing down in '85. There were a few reasons. I had graduated from high school. I had a real job and a real girlfriend. Probably most importantly, though, I was bored. Maybe I could have become a writer like Lee, really focused on art, and only do full cars every now and then. But

the 2 and 5 lines were a disaster because of the cross-out wars and the white trains that the MTA had started to run. So I never became a "strictly full cars" kind of guy. The very last piece I did was a top-to-bottom on the Franklin Shuttle with Paulistic TNC in 1986.

In the late 1980s, Carl Weston developed a passion for filmmaking. I didn't really know what I wanted to do with my life so I thought, "Yeah, filmmaking, why not?" Carl came up with the idea of doing a video magazine about graf, which became the canonical *VideoGraf* series. The idea was to use the profits from *VideoGraf* to fund film projects. I contributed a lot to the first couple of tapes in the series, but then my daughter was born...and I got bored again. Around that time, I was rediscovering my culture and got heavily involved in Reggae and Dancehall music. I contributed some reviews and interviews for fanzines like *BeatDown* and *Dubcatcher*. I even had a sound system for a while.

Writing for the fanzines was fun, but I felt I could reach a larger audience with a TV show. So I took the knowledge and skills from *VideoGraf* and started a show called *RuffKut Reggae*. *RuffKut* was on public access TV from '93 to '98. In the dark days before YouTube, we were one of the most popular public access shows in the city. Our trademark was the video mixes that we did every week. Mixing videos was very hard to do in the days before computers and non-linear editing, but I thought it was fun and it made the show very popular.

My partner on the show was DJ Yonnie, and I would hang out with him while he was spinning in the clubs. I saw him carrying huge crates of vinyl and thought there had to be a better way. I took my background as a hacker and a DJ and wrote a piece of software called SpinStation, which was one of the first digital DJ programs on the market.

I remember some music critics back in the early 1980s predicting that hip hop would only last for a few years. They said the format was too rigid and unimaginative to last for any length of time. What? Rigid? Unimaginative? They clearly didn't understand what hip hop was all about. Thirty-plus years later, I think most people understand that

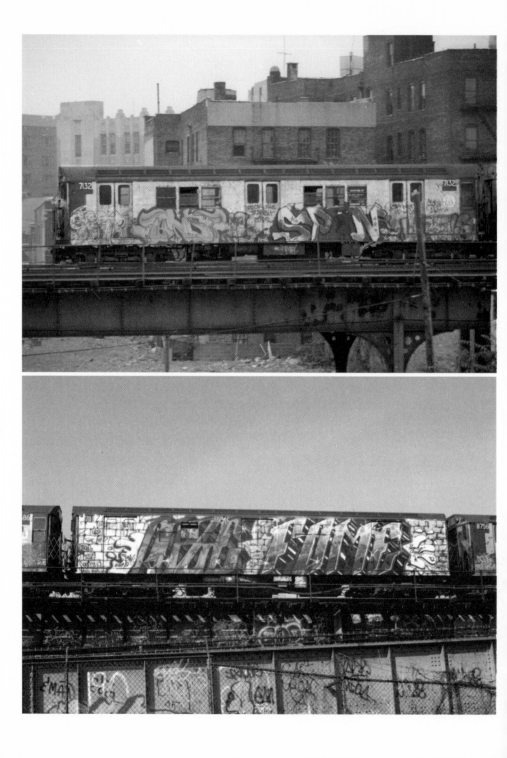

personal expression lies at its very heart. And since everyone has a unique story and perspective, it's something that will continue to adapt and change. It always takes me by surprise when I see graf used in advertising geared towards mainstream America. We were branded as criminals back in the day, and now the art form we created is mainstream and used by rich corporations to sell products. Amazing. I would love to ask the MTA what the difference is between Swatch running ten full cars of ads on the 6 line in 2011 and Erni and other Art & Design writers basically doing the same thing in the 1980s. I guess, to them, it's all about the money.

But it was never about the money for us. It was all about personal expression. That's what makes me feel good about the worldwide explosion of graffiti. Every state, every region, every country, and every writer puts his own personal *spin* on the art form. Ha!

ABOVE And (Magoo), Spin, 2 Seventh Avenue Express, 1982.
BELOW Paze (Erni), Fome (Size), 5 Lexington Avenue Express, 1983.

TEAM

Team grew up in Greenwich Village, just as the shadow of Jimi Hendrix and Cafe Wha? began to fade. It was a land littered with bohemians, intellectuals, the sons of reputed mobsters, and random neighborhood tough guys, but all these varied energies only served to fuel Team's quest for unhinged bursts of self-expression. He traveled where most kids on his block wouldn't dare, and the alliances he formed gave him the freedom to create in peace. His style is like a Grateful Dead poster submerged in a Technicolor fishbowl.

The Greenwich Village I grew up in, in the 1970s, wasn't anything like the Greenwich Village of today. It was very Italian back then, a bit like Little Italy. Whole areas of New York City were owned by specific ethnicities. You had a Puerto Rican neighborhood, an Italian neighborhood, an Irish neighborhood. Unfortunately, my neighborhood was Italian—ha, don't tell KR that!

It was a strange and crazy neighborhood in the 1970s. There was all this cool stuff coming out of Greenwich Village, like Bob Dylan. There were all these smoke and poster shops, and you'd see a lot of hippies walking around. But there was also a lot of violence, and there were weird things happening. There were junkies all over the place.

The Italians were cool with me, but I started meeting other kids through school; mine was a public school, whereas the Italians mostly went to Catholic schools. The kids I met at my school—mainly Jewish and Irish kids whose parents lived in the Village—were more like me. When it was time to go to junior high school, we had to go uptown to 17th Street, so you had kids from the projects entering the mix. A lot of the kids from downtown were scared to go up there. Actually, IS 70—our junior high—was pretty rough. That's the reason why a lot of us downtown kids bonded. We realized that we'd have to deal with it in our own way and started sticking together.

When the graffiti thing hit, we got into it hardcore. When I started the Go Club, which was made up of a whole bunch of my friends, we were all just doing graffiti and looking out for each other. That was at IS 70, around '74. Graffiti was cool. I liked that it was graphic, and the colors appealed to me. When I got to school, I would tag on paper and on the chalkboard. Everybody in school had a tag—all the girls, too—with the number of the street they lived on. For some reason, I didn't get into the numbers. I didn't want to put the number of my street; and in any case, in the Village, there aren't really any numbered streets. I wanted to do something a little more modern. I started off thinking that "Team Go" might be cool—like a "Go, team, go!" kinda thing—and that led to the "Go

TEAM

Club." We got our crew together and started bombing. My biggest influence was definitely Max 13YB, a really cool dude from uptown. We became good friends and would go to tunnels and yards together. He introduced me to a lot of people. We would run into people like Stay High 149, Cliff 159, and Blade. Everybody knew Max. We stuck out because we were the white and black dudes, Team and Max. Lots of people became aware of who we were—guys like Lee—and started to say they liked what we were doing. From Max, I learned the ropes.

Max was from 125th Street on Broadway. He lived right next to the 1 train, which was pretty cool. I'd tell my parents I was staying at Max's house and then we'd break out at like 3 a.m. and go to the 1 tunnel, which is right up there. That's how I got my start on the subway. One of the cool things about writing was the fact that you didn't know what color someone was, or who they were, from their tags and pieces. When you did meet them, you'd be like, "Oh yeah, you're..." But you couldn't tell their ethnicity just from seeing their work, because everybody wrote. For me, writing graffiti was a vehicle for branching out, meeting new people, and getting around. I felt that kids from different neighborhoods—like up in the Bronx—were the same as me. They didn't want to just stay in their neighborhoods and were keen to meet other people, too. That's one of the best things about graffiti: there's no consciousness of race. Nobody ever says it was the blacks who started it, or the whites. It's purely about style, and that's what lured me in.

I loved the 1 line on Broadway. It was my favorite line and was convenient for me to get to. I could easily go uptown to the 1 tunnel or to the 1 yard in Riverdale. Where I lived in the Village, there really weren't that

FROM TOP TO BOTTOM Go Club car, *ca.* 1979; Fuse, Team, 2 Seventh Avenue Express, 1977; Fuse, Team, 1 Broadway Local, 1978; *Urban Blight* by Team, 1977.

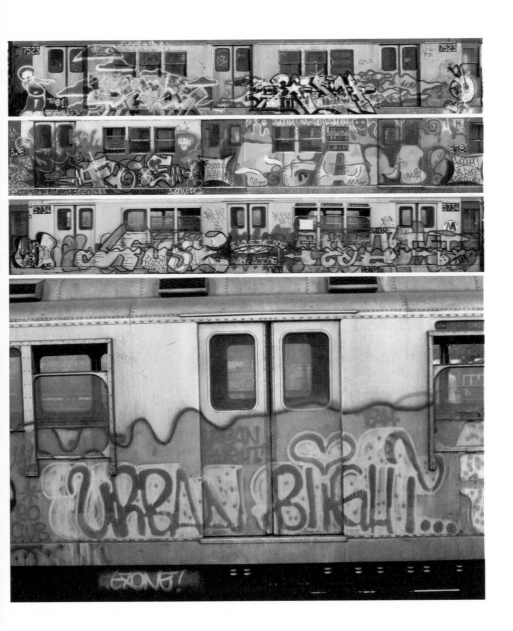

many yards or tunnels. The kids from Brooklyn, the Bronx, and Queens all had train yards in their neighborhoods. I got into hitting some places in Brooklyn, like down in Utica and the tunnels, but I mainly stayed on Broadway. And I always felt that it was the coolest line simply because it was Broadway—number one... That line goes right through the middle of Manhattan. What could be better than that?

Style was everything to me. Everything else was inconsequential—even getting arrested, which happened a few times. I was like, "I got my paint, I got my style, I wanna get in there." The adrenaline rush would kick in, I'd get off some really cool pieces, and then get out of there. To stay safe, you had to learn the ropes, and in fact I did meet a lot of people who were like "Don't do this" or "Don't do that"—"The third rail, don't go down that way." Once you've learned everything you can—and there is a lot to learn—you have to just go and do it. Going bombing for the first time is very scary. Some kids couldn't handle it. If you went with four guys, two of them would just leave—run away. My partners were always guys who could stick it out.

As far as beef, I tried to avoid it myself. Some older guys would roll up on me and try to jump me, but I was pretty used to it from growing up downtown. I wasn't really fazed by guys trying to be hard. And while I personally wasn't gonna go around beating people up, I wasn't gonna let them beat me up either.

No one's family is ever happy about the graffiti thing. My mother had a hard time with it. But I think that, ultimately, my parents were kinda glad that I wasn't getting arrested for doing something else—you know, like at least it was just graffiti. A few times, I was able to go under the radar with my family. I would tell the cops that I had a surrogate mother and give them the number of a friend of mine whose mom was a cool weed dealer. The cops would call her up and she'd be like, "Yeah, that's my son. Okay, yeah, we'll get him." I guess you couldn't do that nowadays with computers and everything, but back then they were just like, "Your son is here." But a couple of times I did have to spend a few nights in the

clink and that wasn't good. That's when your parents know things are bad. I think they handled it OK. I told them I was gonna stop.

I wanted to keep my tag really tight. It was sort of designed to rock with a Mini-Wide or a Uni-Wide, so that it could be written in a certain way, like calligraphy. That's kinda what influenced me, along with the guys who had that kinda style—like Jester, who had an incredible tag, and Mico.

We were lucky because Red Devil paint was great back then. It was really thick. All the spray paint had lead in it, which I'm sure wasn't good in terms of breathing it in, but it did make the best spray paint. Krylon, Red Devil, Rust-Oleum, Wet Paint—that stuff was so thick, and the colors were really vibrant. I was a young kid with no money, so I had to steal all my paint. That was something we all had to learn to do, and I have to say, I got pretty good at it. Luckily, in my neighborhood there weren't a lot of graffiti writers, so the hardware stores didn't really know what was up. There used to be these five-and-dime stores that carried paint—like Woolworth's, which had plenty of Red Devil. You'd go down the aisle and shove it up your coat, down your pants, or in your belt, and then just walk out like a straw man or something.

My peak years were between '76 and '78. Then, I graduated from high school in '78 and that's when I pretty much stopped. I got arrested around that time and the cops were threatening me with a felony, but the judge was like, "He's under age. You gotta be kidding me." I remember saying that when I turned 18, I was going to quit. They made me clean some stations down in Brooklyn for a few weeks—that was no problem. The serious ramifications of graffiti weren't for me, and by '78 it had started to fade out in general. Graffiti wasn't that big until the next wave came in the early 1980s, when spaces like the Fun Gallery opened. When I quit, it seemed like nobody was really that into it anymore.

When Lee used to put out those whole cars back in my day, it would be all anyone talked about at my school: "Shit, did you see the new one with Jaws...?" People talked about it because it was cool. It was almost like hip hop. It felt like everybody had heard it. Everybody was talking about it.

By '78, that vibe had gone. So that was it for me. I went to Erasmus Hall High School in Brooklyn, which has a lot of graffiti history. A lot of the Ex Vandals went there. Occasionally, I would find lost tags in the school from guys like Dino Nod and Mico—generally in these little enclaves we'd find, where we could smoke weed. People would refer to me as a graffiti writer... Wow. Yeah, I remember they used to do that.

I started playing in a band called Urban Blight and got more into music. I had a job at a small supermarket that sold magazines. I remember this one magazine had a whole article on the Fun Gallery. It was about Dondi, Zephyr, and Futura, and I remember thinking, "Man, they're keeping it going. Cool." I wasn't looking to bomb trains or anything, but gradually people started approaching me to paint with them. So I never really stopped drawing and piecing.

Music was a big part of the experience. Growing up in the 1970s, music culture was huge. It went hand in hand with writing. I often think of the music that would be in my head when I was in the lay-up. I spent hours and hours in my house working on my style—black books, doing outlines, working with Design markers—and would listen to music while I was working through my ideas. Graffiti writers are creative people, and it was natural for many of us to fall into music.

Mackie, who also wrote Hyper, played in the band with us for a long time. He had a really cool style and is an amazing drummer. He was writing when I was, in the 1970s, and kept piecing into the 1980s, so a lot of people know him from that period. Blade: I see pictures of him with his bass, wearing his cowboy hat and stuff. That dude is crazy talented. You only have to look at some of the pieces he did—they're unbelievable. I bug out on people like KRS, who used to tag. He had a pretty cool tag, too. I'm sure there are many others who played music—people I don't even know about, you know?

I never would have thought graffiti would be as big as it is now. I didn't even take that many pictures because I didn't think it really mattered. But nowadays, it's just so incredibly blown up. I still enjoy it.

I try to stay on top of who's doing what, and still get out there. I'm pretty amazed that it took off like it did, but it's become a legitimate art form in many ways, so that's very cool. Of course, there will always be those who question whether it is an art form or a form of vandalism—the same old debate. Graffiti is an art form, without a doubt: it's got style, guidelines, and ways to do things. I feel privileged to have witnessed the evolution of this new art form first-hand, from its beginnings to the powerhouse it is today.

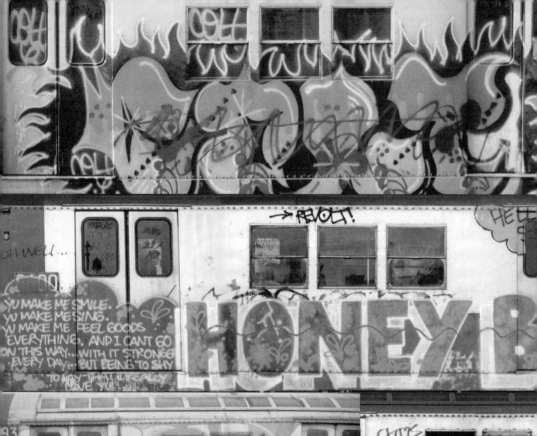

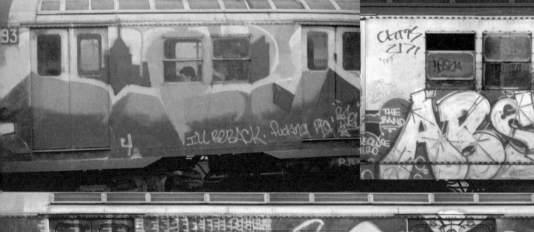

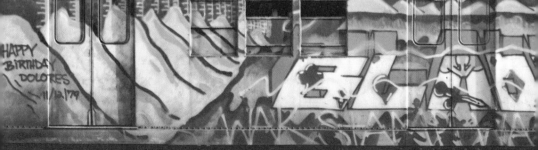

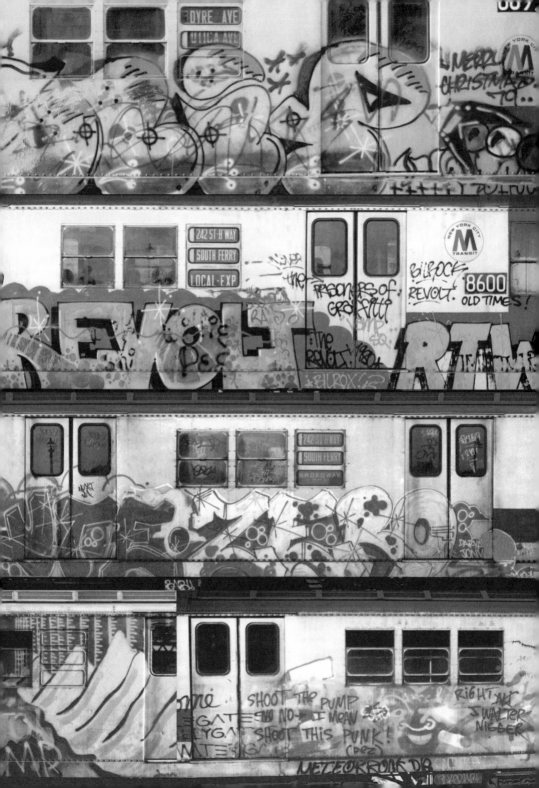

Glossary

5-0
euphemism for police officers. Derives from the hit 1970s television drama *Hawaii Five-0*.

background a piece
when a graffiti artist doesn't completely cover another graffiti artist's work on a subway car. The thinking is that if you completely cover someone, no one knows. But if you partially cover someone—and others can recognize who has been covered—the act is considered to be a serious sign of disrespect.

biting
to blatantly ape someone else's style; to steal someone else's style.

black book
sketchbooks commonly used by graffiti artists. Many have black covers.

bomb
to aggressively write graffiti.

buff
to clean or to have graffiti washed or scrubbed off a surface.

burner
an exceptional piece or composition.

cap
the nozzle that regulates the flow of spray paint (affixed to a can of paint). A fine cap produces a thin concentration of spray. A fat cap delivers a broader concentration of spray.

catwalk
planks of wood that trackworkers and graffiti artists walk on when making their way on elevated tracks.

end-to-end
a painting that spans from one end of a single train car to the other.

fill

the core color of a piece.

flooded marker

magic marker teaming with ink.

full car/whole car

a painting that spans the length and height of an entire train car.

Ghost Yard

infamous train yard situated in the Inwood section of Manhattan.

hook-up/doo-dad

painted details that might enhance a piece.

IRT

Interborough Rapid Transit was the private operator of the original underground New York City Subway line, which opened in 1904, and was purchased by the City in June 1940. The former IRT lines are the numbered lines in the current subway system.

kill

to do a whole lotta graffiti writing…

king

one who is respected either for the amount of work they've done or recognized for the advanced nature of their work (or both).

lay-up

a stretch of track where trains are parked when they are not in service.

married couple

two separate train cars that are permanently joined together.

MTA

The Metropolitan Transportation Authority (MTA) is responsible for public transportation in the U.S. state of New York, as well as operating several toll bridges and tunnels.

Noga (Nation of Graffiti Artists)
A non-profit organization founded in 1974 that fostered the talents of young graffiti artists.

outline
the lines that define the edges of a piece.

piece
a graffiti painting, shorthand for "masterpiece."

prez
the president of a crew or writing group.

rack
to steal paint (derived from the paint racks that the paint is "borrowed" from).

throw-up
a speedily done, bubble-based letterform that is often utilized as a way to get your name up quickly.

top-to-bottom
a piece or throw-up that spans a train from top to bottom.

wild style
a style said to have been pioneered by Tracy 168; has also gone on to symbolize the abstract nature of some graffiti paintings.

window-down
a piece or throw-up that lives below the windows on a train car.

Index

Page numbers in *italic* refer to illustrations.

A One 54, *61*, 62, 63, 68, 124
Active *see* Sak
Ad Rock 31
Adams, Neal 143
Agent 95, 112, 134, *135*, 138, 139, *140–41*
Airborne 133
Alia *61*
Alive 5 106
Astor, Patti 124
Aze *78*

Baby Rock 133
Ball Busters 30–31, 33, 59, 110, 133
Ban 2 59, 60
Bando 66, 67
Bandshell 23, 31
Barbara 62 92
Basquiat, Jean-Michel 28, 32, 100
B-boy *19*
Bil Rock 22–33, 89
Billy 167 123, 136
Blade 18, 36, 45, 49, 51, 72, *135*, *155*, 162, 166
Bomb 1 30
Boozer 30
Breezer 34–43, 118
Buscema, Sal 143
Butch 2 33, 46, *50*, 51, 112
BYB (Bad Yard Boys) 45

Cap 38, *40*, 100, 133, 134, *135*, 152, 153–54, *155*, 156

Cat 87 23
CC 153 59
Chain 3 46, 138–39
Chalfant, Henry 10, 11–15, 20, 21, 36, 49, 94, 109, 142
Chan, Ernie 143
Chaz *107*, 108
Chino Malo 45
Chisy 89
CIA (Crazy Inside Artists) 28, 31, 115, 134
Cliff 159 45, 47, 86, 162
Comet 36, 46, 47
Cooper, Martha 21, 49
Cope 2 152
Cornbread 87
Cos (Cos 207) 30, 33, 76, *78*, 79
Crash 28, 33, 46, 54, 59, *78*, 79, 93, 95, 127
Craze 72
Crazy Legs 67
Crunch 24, *25*
CYA (Crazy Young Artists) 57

Dar (Darizm) *125*, 126
Daze *14*, 44–57, 59, 76, 93, 95, *131*
Dean 45, 49, 85, 86, 89, *90*, 91
Delta 2 62, 115, *116*, 117, 119, 120, *121*, 122, 124, *125*, 126
Dez *14*, *51*, *58*, 59, 115, *131*, *132*, *135*, 146, 152

Diaz, Al 28, 30, 32
Dino Nod 166
Doc *13*
Don 1 45, 49, 84, 85, 86
Dondi *14*, *15*, 27, 28, 30, 51, 87, 93, 146, 166
Doze 45, *47*, 59, *96*
Duro *78*, 82
Dust 36, 38, 41, 119
Duster 34, 123

Era *62–63*
Erni 89, *90*, 93, *96*, *158*, 159
Esses, Sam 32–33
Eva 62 92

Fabulous Five 72
Fashion Moda 50, 52, *53*, 94, *135*
Fats 153 59
FBA (Fast Breaking Artists) 63, 105, 110, 112
5 Percent Doctrine 138
FK 66
Flite 60, *61*, *62–63*
Foam *see* Size
Frank TNS (They Never Stop) 59
Freddy 30
Frozen 105, 106
FTD 56 74
Fun Gallery 32, 33, 165, 166
Fuse *163*
Futura 30, 32, 33, 59, 93, 166
Fuzz (Fuzz 1) 31, 49, 51, 55, 136

Ghost Yard 39, 65, 95, 105, *111*, 112
G-Man *19*, 120, *121, 123*, 152
Go Club 28, 161–62, *163*

Haring, Keith 100
Hash 149, 153
Haze 23, 24, 31
Hot Tuna 27
Hyper *see* Mackie
Hypo *see* Sak

Inca 45
IRA (Irish Republican Army) 110
Iz the Wiz 27, 30, 51, 63, 71, 99, 101–2

JA 68
Jade 72
Jam 2 118
Jayson 27
JB 89
Jean 13 57
Jenkins, Sacha 17–21
Jester 165
Joey *125*
Jon One *14*, 58–69, 127
Json 154

Kanzaki, Rii 153
Kase 2 28, 33, 46, 49, 51, 95, 120, 137, 146, *148*
Kaze *61*
KB TSS (The Squadron Supreme) 85
Kel 28, *29*, 33, 55, 70–83, 94

Kid 56 46, *73*, 74
Kirby, Jack 143
Kool 131 134, *135*, 137–38, 139
KR 84–91, 161
Krazy Boy (KB) 89
Krazy Nick (KN) 89
Krazy Rudolpho 89
Krazy Writer (KW) 89
Krazy Zap (KZ) 89
KRS 166
Kyle 58, 61, *62–63*, 68

Lady Heart 98–99
Lady Pink 45, 91, 92–103
Lee *13*, 36, 61, 89, 93, 94, 98–99, 100, 137, 146, 156, 162, 165
Lennon, John 101–2
Little Ali 23, 31
Loomit 68

Mace 85, 89
Mackie 59, 104, 106, 166
Magoo *148*, 149, *158*
Malta 23, 24, 31
Mandate 79
Marc *139* 94, 102
Mare *78*
Max 1 3YB 162
MBT (Masters Burning Together) 106, 108, 110
Me 62 38
Mean 129–31, *132*
Mercenaries 138
MG (Mission Graffiti) 27, 51
Mico 165, 166
Midge 89
Min 24, *26*, 27, *29*, 63, 65, 82

Mitch 77 36, *37*, 49, 51, 136
Mob 27
Mode 2 67
Mono *13*
MPC (Morris Park Crew) 38, 133–34
MSK (Mad Society Kings) 65
MTA (Mad Transit Artists) 143, 147, 149, 153, 156, 157, 159
Myzer 149

Nac *50*, 55, *56*
NWA (New Wave Artists) 89
Noc *167* 49, *50*, 51
Noga 23, 51

156 crew 68
1 tunnel 27, 110, *111*, 162, 164

Pade 28, 30
Padre 49
Pain 1 136
Part 71, *73*
Paulistic 153, 157
Paze *see* Erni
Pelsinger, Jack 51
PGA (Professional Graffiti Artist) 152
Phase 2 62, 87, 112, 131, *132*
Piggy 28
PJay 34
Pore *132*
Pro 86
Psyckose 68

Quik *26*, 27, *29*, 59, 63

Rac 7 60–61, *62–63, 111,* 112
Rasta *26,* 27, 30, 31, 33, 59, 133–34, 146
Reas 113
Regal 192 30
Rek *50*
Reka *107*
Revolt 24, *25,* 27, 31, 153
Rin 1 30, 32
Rize 106, 110, *111,* 112
Rob 78 85
Roc Stars 76, 79
Rom One *90*
Roxy 67
RTW (Rolling Thunder Writers) 22–29, 31, 68, 89, 115
Run 106, 112
Run DMC 18

Sach 27, *29*
Sak 104–13
Samo 32
Samurai *26,* 27
San 2 152
SE 3 59, *140–41*
Seen TC5 45, *47,* 94–95, 152
Seen UA 34, 36, *37,* 38, 41, *42, 61,* 62, 119, 123, 146, 154
Sharp 68, 114–27, 153, *155*
Shock 30, 32
Shoe 66
Shy 28, 76, *78,* 79
Sick Nick 89
Sign 66
Siko 30
Silver, Tony 142
Sin 35, 36, 39, *42*
Siner *40*
Size 89, *90, 158*

SK2 117
Skeme *14, 53,* 63, 95, 108, 112, 115, 128–41, 146
Slick 86
Slin 2 156
Sneak 66
Son 86
Soro 144–45
SA (Soul Artists) 23, 24
Spicter 65
Spin 142–59
SS 98
Stash *122, 155*
Stash 2 153
Stay High 149 87, *162*
Steve 62 23
Strike 27
Swan 3 106, *155,* 156
Swatch 159
Swift, Ken 66, 67

T Bag 138–39
Tack FBA 110
Taki 183 23, 87
TC5 (The Cool Five) 94, 95
TDS (The Death Squad) 51, 112
Team 160–67
Tekay 147
Terror 134
TFA 68
TFP (The Fantastic Partners) 59, 133, 153
3YB (Three Yard Boys) 45, 68
T Kid 30, 31, 32, 60
TMT (The Magnificent Team) 31, 112, 129, 133–34, 136, 139
TNT (The Nation's Top) 27
Tony, C.R. 145
Top, James 12, 65

Tracy 168 33, 51, 59
Trap *51, 58,* 59, *131*
Trim 153
TSS (The Super Squad) 31, 89
TVS (The Vamp Squad) 30, 133
2Bad *40*
2Mad 45, 46, 57, *58*
2 New 65

UA (United Artists) 35, 38

Vamp Squad 115
Vandal Squad 20, 149, 166
Venerable Intruders 153

Warhol, Andy 100, 123
Web 147, 149
Weston, Carl 152, 156–57; *see also* San2
Wheat 1 59–60
Writers' Bench 46, 49, 51, 72, 152

Zephyr 24, *25,* 27, 31, 32, 33, 59, 93, 124, *125,* 146, 153, 166

OVERLEAF
KZ in the Brooklyn scrap yard.

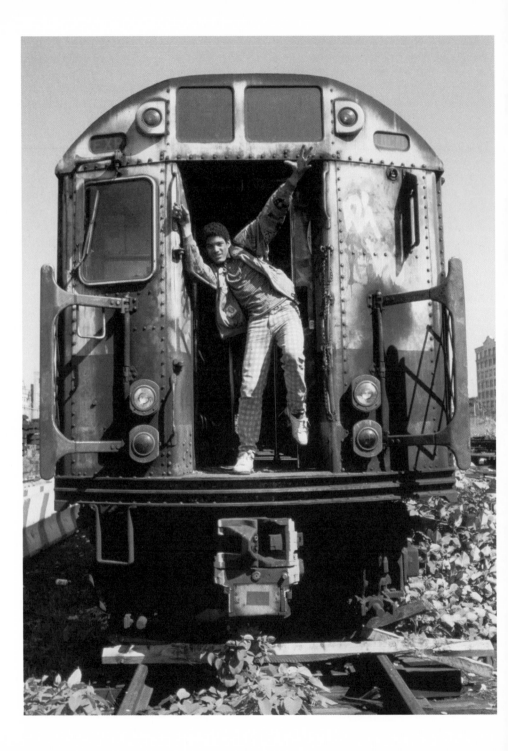